HADRIAN'S WALL

Paintings by the Richardson Family

THIS BOOK IS PUBLISHED WITH THE AID OF GRANTS FROM

The Trustees of the Clayton Collection

The Roman Research Trust

The Cumberland and Westmorland
Antiquarian and Archaeological Society

The Society of Antiquaries of
Newcastle upon Tyne

The Marc Fitch Fund

The Society for the Promotion
of Roman Studies

Tyne and Wear Archives and Museums

The Hadrianic Society

HADRIAN'S WALL IS A WORLD HERITAGE SITE

HADRIAN'S WALL

Paintings by the Richardson Family

David J. Breeze

JOHN DONALD

For Frances and John in the year of their marriage

First published in Great Britain in 2016 by
John Donald, an imprint of Birlinn Ltd

West Newington House
10 Newington Road
Edinburgh EH9 1QS

www.birlinn.co.uk

ISBN: 978 1 910900 05 5

Copyright © David J. Breeze 2016

The right of David J. Breeze to be identified as the author of this work
has been asserted by him in accordance with the Copyright, Designs
and Patents Act, 1988

British Library Cataloguing-in-Publication Data
A catalogue record for this book is available on request from the
British Library

Designed and typeset by Mark Blackadder

Printed and bound in Latvia by Livonia Print

Contents

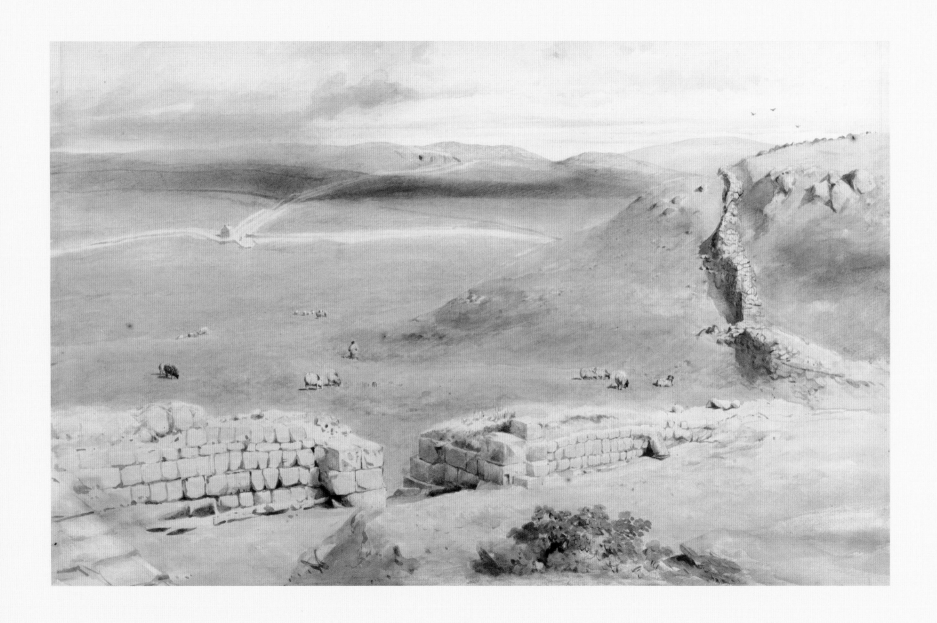

Foreword

I had never seen the pictures in this book before and to be honest I had never heard of the artist, Henry Burdon Richardson, or his various artist brothers. I knew about his dad, Thomas Miles Richardson, and I knew a bit about John Clayton and John Collingwood Bruce, the other principal characters in this fascinating story of the rediscovery of the Roman Wall, but Henry Burdon Richardson was new to me and I am thrilled to bits to have made his acquaintance because I think his pictures are enthralling.

Some of them, of course, show scenes that no longer exist, places where the remorseless growth of urban and industrial Tyneside has obliterated ruins and remnants that were available to those earlier explorers and there is a sort of melancholy, archaeological interest in those pictures, a fascination at seeing what Tyneside was like in those days – but most of the pictures are brilliantly and instantly recognisable and I was struck by how little the scenes have changed. It seems clear that Richardson was as moved by the wild, bleak landscape of Northumberland as we are today and he has conveyed it in all the misty emptiness that we still love today.

But the pictures are more than landscape paintings; they are also pictures of stones, evocatively detailed images of ancient stones emerging out of the soil and it is extraordinary how little these scenes have changed as well. Presumably there are places nowadays where there are more stones to look at, where excavation has revealed more of the ancient landscape, but the texture and the atmosphere of The Wall was captured and, it seems to me, almost frozen at the moment it was first noticed and recorded. What Richardson painted allowed academics to understand the archaeology but he also made clear the more intangible

OPPOSITE. The south gate at Cawfields by Henry Burdon Richardson

vii

qualities in the scenes – that wonderful combination of history and place which remains the essence of The Wall and the source of its remarkable power.

When these paintings were done and Collingwood Bruce began to tell the story of The Wall, audiences were 'surprised that so magnificent a monument of the power of Rome existed within easy reach of their homes'. Within a few years everybody knew and all three of the main characters in this book had a part to play in making the story known. John Clayton used his fabulous wealth to buy and preserve vast numbers of the sites we love so well today. Collingwood Bruce, the brilliant communicator, told their story and led the way for a whole army of future enthusiasts. Both of these men are justly honoured for the part they played in saving our heritage, but it tickles me no end that the painter, who was by far the poorest of the lot of them and who was barely acknowledged at the time, but who showed The Wall in all its complex beauty, should finally have been allowed to emerge from the shadows.

John Grundy
NEWCASTLE UPON TYNE

Preface

This is the story of three men, John Collingwood Bruce (1805–1892), Henry Burdon Richardson (1826–1874) and John Clayton (1792–1890). In different ways they were responsible for creating the modern perceptions of Hadrian's Wall through their books, paintings and excavations over the sixty years from 1832 to 1892. In that period John Clayton acquired five forts and many miles of the Wall in the central sector, putting his workmen to the task of examining buildings and 'restoring' the Wall. Bruce wrote books describing the Wall and was the great interpreter of the monument for forty years. Richardson is less well known, but his many paintings of Hadrian's Wall undertaken in 1848 provided the illustrations for Bruce's lectures the following winter which sparked interest in the Wall; several of his paintings were the basis for the engravings that appeared in Bruce's books. The intimate relationships between their activities are summed up in Appendix 2 on page 173.

Richardson's paintings, and those of his brothers, Charles and Thomas, have dropped out of public consciousness, but they provide a valuable record of Hadrian's Wall at a most important stage in its history. New theories and ideas had just appeared, to be popularised in Bruce's first book *The Roman Wall*, published in 1851. Clearance of the ruins had just started and was to gather momentum through the following decades, and this act brought to light new information which changed interpretations of the Wall. Bruce's lectures in 1848, and then his books, encouraged new visitors, starting with the first Pilgrimage of Hadrian's Wall in 1849. A small affair, with only 24 participants, the event nevertheless survived and has continued to the present day, with over 200 people anticipated at the next one in 2019. These Pilgrims will be able to view far more stone-work that their forebears in 1849, and be offered detailed explanations unavailable then, but that is only possible through the work of John Clayton,

John Collingwood Bruce and Henry Burdon Richardson.

In other ways, the legacies of John Collingwood Bruce and John Clayton continue to this day. Bruce's *Handbook to the Roman Wall* has been continuously revised since his last edition of 1885, most recently in 2006 (Breeze 2006, 2007). Two of Clayton's forts, Vindolanda and Carvoran, are in the care of the Vindolanda Trust, while Chesters and Housesteads, together with Birdoswald and Corbridge and many lengths of Clayton's Wall, are in the care of English Heritage. The National Trust owns most of the Wall between the Knag Burn and Cawfields, including not only the Wall and Vallum but the fort and extra-mural settlement at Housesteads, five milecastles, several turrets, Haltwhistle Burn fort and several temporary camps.

David J. Breeze

Acknowledgements

I am grateful to Sarah Richardson, Keeper of Art at the Laing Art Gallery, for her support and assistance with Richardson paintings, Adrian Gibbs and Duggan Collingwood of Bridgeman Images, and Andrew Parkin of the Great North Museum for help with the Thomas Miles Richardson junior paintings. I am further grateful to Paul Bidwell for making available to me a copy of the 1886 list of paintings and the catalogue of an exhibition of the paintings, Nicholas Hodgson for providing access to the Bruce archive at Arbeia Roman Fort and Museum, Jackie Henrie for useful discussion about printing processes in the middle of the nineteenth century, Frances McIntosh for help with the Clayton family as well as for reading and commenting on my earlier drafts, Professor Tony Birley for reading and commenting on an earlier text, Graeme Stobbs for helping with identifications, and Tony Kirby and John Pickles, librarian of the Cambridge Antiquarian Society, for information on Bruce's lecture to that body in 1882.

The paintings are reproduced by kind permission of the Laing Art Gallery and the Great North Museum: Hancock, both part of Tyne & Wear Archives & Museums, the latter managed on behalf of Newcastle University. I am grateful to the following for permission to reproduce illustrations: English Heritage Museums (page 10); Grace McCombie (page 30); Newcastle upon Tyne Hospitals NHS Foundation Trust (page 6); the Society of Antiquaries of London (page 7); the Society of Antiquaries of Newcastle upon Tyne (pages 4 and 144); Tullie House Museum, Carlisle (page 164).

Author's notes

The main source for the life of John Collingwood Bruce is the biography by his son Gainsford (Bruce 1905; cf. Edwards 2009). Marshall Hall's *Artists of Northumbria* provides valuable information on the Richardson family. Clayton is not so well served. Many of his papers were destroyed after his death. There is a notice in the centenary volume of the Society of Antiquaries of Newcastle upon Tyne (*Archaeologia Aeliana* 3rd ser., 10 (1913) 182–5) and in Wallis Budge's catalogue of the museum at Chesters (Budge 1903, 1–24). There is no attempt here to provide a full bibliography for the sites discussed in the text. For detailed references see David J. Breeze, *J. Collingwood Bruce's Handbook to the Roman Wall*, 14th edition, Newcastle upon Tyne (2006). References are provided in relation to the illustrations where appropriate.

The milecastles (MC) and turrets (T) on Hadrian's Wall are all numbered from Wallsend westwards, and are usually cited with the names as well as numbers, for example, MC 42 (Cawfields), T 42a (Burn Head), T 42b (Great Chesters). Here, 'Wall' is used to refer to the whole of the frontier works, 'wall' to the linear barrier itself. Dates are AD/CE.

In 1886 a list was created of the paintings held at Bruce's house. This was published in booklet form after Bruce's death (*Drawings* nd). A catalogue of those paintings displayed in the Laing Art Gallery in 1906 also survives.

The descriptions in these lists are similar, though in the 1906 catalogue the wording of the 1886 list has been modernised.

The main paintings in this book are arranged in order of location on the Wall travelling from east to west (see also the map on pages 168–9), which was the direction of Bruce's 1848 tour and subsequently of his books. Each entry takes the following form:

* title and description of the painting as it appeared in the list prepared in 1886;
* the name of the painter;
* comment from Bruce in his first edition of *The Roman Wall* where appropriate;
* further information;
* references to the publication of the paintings as engravings in Bruce's books, including
 Views: J. C. Bruce, *Views on the line of the Roman Wall*, 1851; unpaginated
 Drawings: the 1886 list, published after Bruce's death (Anon. nd);
* the Laing Art Gallery reference number.

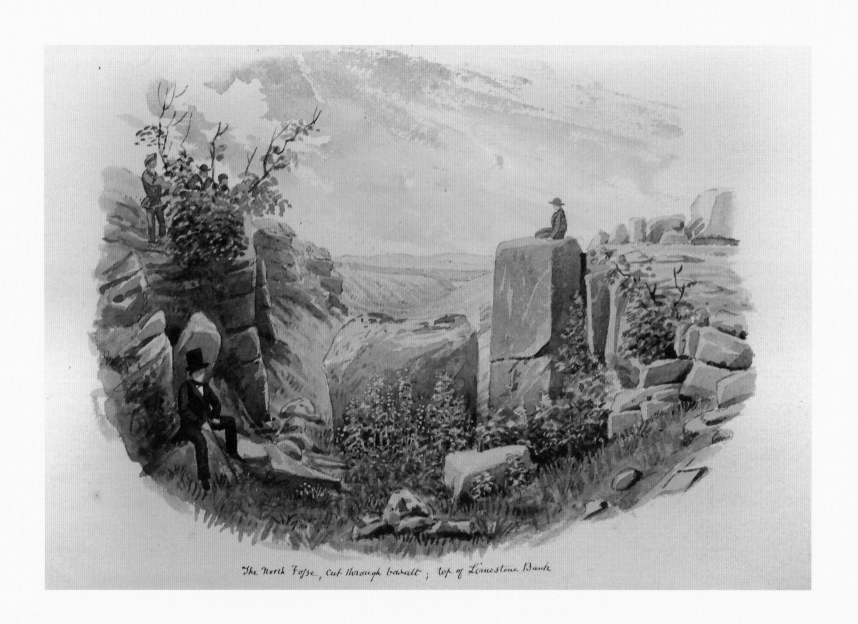

The North Fosse, cut through basalt; top of Limestone Bank

The creation of the paintings

In 1848, John Collingwood Bruce, a schoolmaster in Newcastle, was prevented from going on holiday to Rome because of the revolutionary fever gripping the continent; instead, he went to Hadrian's Wall. In the words of his biographer, his son Gainsford Bruce, he then 'devoted Saturday afternoons and the whole holidays to examining the remains in the neighbourhood of Newcastle and the more distant portions of the Wall' (Bruce 1905, 110). On his main trip, in June of that year, he took with him two brothers, Henry and Charles Richardson, who were local artists.

Henry and Charles were the sons of a famous local painter, Thomas Miles Richardson. He had been 'drawing master' in Bruce's school, the Percy Street Academy (Bruce 1905, 69–70). When he retired, several of his sons succeeded him in turn: Thomas Miles junior, Edward and then Henry. It was this connection which led Henry and Charles to accompany Bruce on his expedition along the Wall. They had instructions to put archaeological accuracy before artistic licence in their record of the Wall.

Some details of the tour survive in Bruce's biography (Bruce 1905, 110–13). On 19 June 1848 the party – Bruce and his son together with Henry and Charles and at least one servant – arrived at Chesters, the house of John Clayton, a local landowner and owner of a several miles of Hadrian's Wall. In his letter to his wife written that evening, Bruce said, 'Richardson has made two or three very useful and one very beautiful sketch.' The whole journey through to Bowness at the west end of the Wall took about ten days and, during that time, 'Mr Henry Richardson made sketches at the most important points along the Wall.'

In the autumn of that year, Bruce gave a course of five lectures to the Literary and Philosophical Society in

OPPOSITE. John Collingwood and Gainsford Bruce at Limestone Corner

1

Newcastle about the Roman Wall, as Hadrian's Wall was generally called then. The first lecture, on 15 November, was a general introduction and with the second he started a description of the surviving remains, illustrated by Henry and Charles Richardson's watercolour sketches. The lectures were well attended, but his audiences were surprised that 'so magnificent a monument of the power of Rome existed within easy reach of their homes, and had remained comparatively unobserved and unnoticed' (Bruce 1905, 114). In response, Bruce agreed to lead a special tour of the Wall in the following year, a visit which became known as the first Pilgrimage of Hadrian's Wall; the fourteenth decennial Pilgrimage will be held in 2019 (for a bibliography of the Pilgrimages see Edwards and Breeze 2000).

Knowledge of Bruce's interest in the Wall soon spread beyond Newcastle. He was invited to read a paper at the British Archaeological Association meeting in Chester on 2 August 1849. This was well received – the lecture and discussion lasted nearly four hours. This appears to have been the occasion when Bruce decided to turn his material into a book, as a review in the *Journal of the Archaeological Association* (25 April 1851) was to acknowledge. Events moved quickly for on 9 August 1849 Roach Smith wrote to Bruce to subscribe for a copy.

Bruce spent the next 16 months researching, revisiting the Wall to check details, writing and having engravings

(then generally known as lithographs) as the main illustrations, prepared from Henry Richardson's paintings. He completed the preface on 1 January 1851 and the following day sent the first copy of the book to his wife. The book had presumably already been typeset by 1 January and all that was required on that day was for the four pages of the preface to be set and the first folio of 24 pages to be printed and bound with the rest of the book (the first copies arrived in London on 4 January). The book was published at Bruce's own expense, though the Duke of Northumberland and John Clayton both covered the cost of some illustrations (Bruce 1905, 125–6).

The Roman Wall, or, to give it its full title, *The Roman Wall: A Historical, Topographical and Descriptive Account of the Barrier of the Lower Isthmus, extending from the Tyne to the Solway deduced from numerous personal surveys*, quickly sold out, and Bruce started to prepare a second edition. This was published on 17 December 1852 but dated 1853; a third edition followed in 1867. A separate production in 1851 was *Views on the Line of the Roman Wall*, of which only 21 copies were published. This contains just 16 views, all engravings. Eleven are based on Henry Richardson's paintings, two are by John Storey (*The Crags, West of Crag Lough* – based on the engraving in Hodgson (1840, opposite p. 290) – and *Written Rock in the River Gelt*), two by Charles Richardson (*Wallsend, Looking East* and *Heddon-on-the-*

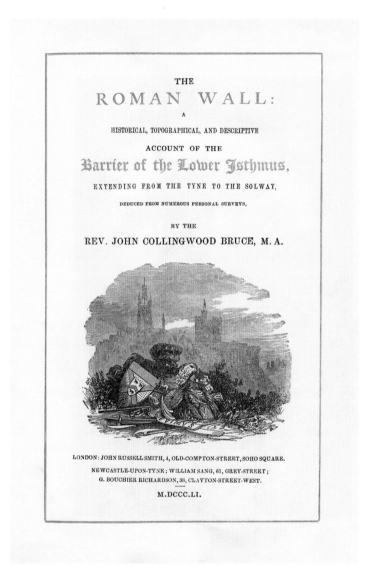

Wall) and one by George Bouchier Richardson (*Pons Aelii, Restored*). To date, with the occasional exception, Richardson's work on Hadrian's Wall has only been published in the form of engravings in Bruce's books, and even then less than half of Richardson's paintings were turned into engravings. None of the Richardson family's paintings, nor the engravings which resulted from them, were used in any of the three *Handbooks* to the Roman Wall published by Bruce (1863, 1884, 1885), except as woodcuts.

LEFT. The front page of the first edition of *The Roman Wall*

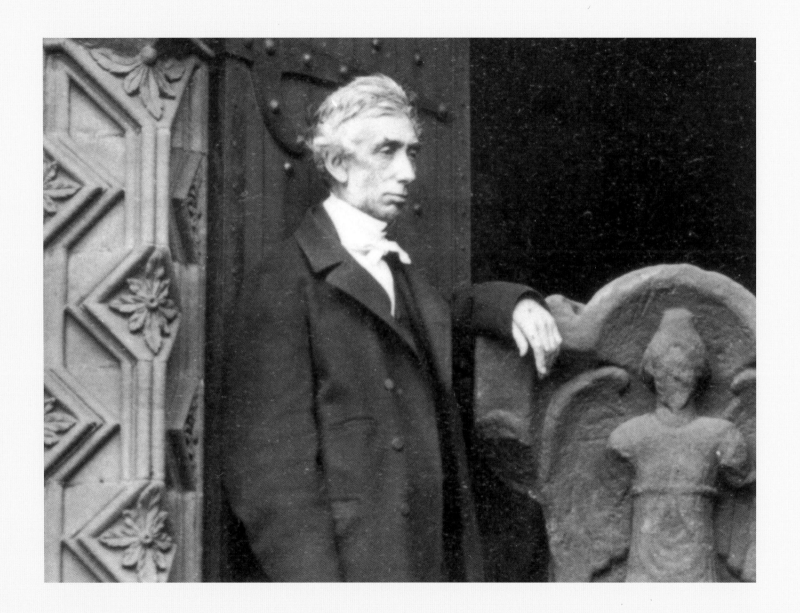

John Collingwood Bruce

John Collingwood Bruce was born in 1805, the son of John Bruce, who, with his brother Edward, ran the Percy Street Academy in the Haymarket at Newcastle, which opened in 1806. John Collingwood (named after his grandmother's foster mother and not the admiral of that name) attended both Glasgow and Edinburgh Universities and was licensed as a preacher in 1829. He spent two years preaching to Presbyterian congregations both north and south of the border, but in 1831 joined his father in the running of the school. On the death of his father in 1834 he took over sole management of the school, continuing as headmaster until 1860.

John and Edward Bruce had published school textbooks on geography and history, and John Collingwood continued to update these. He also began to use historical architecture as a teaching aid for his pupils and he took them to see important historic buildings. By the late 1840s he was giving lectures to wider audiences on the subject. This led him to an interest in Newcastle Castle, then in sore need of attention. He took the lead in organising the repair work and produced a guide to the castle. At the celebratory banquet in the great hall of the castle keep in 1848 to mark the completion of the conservation work, Bruce met the Duke of Northumberland for the first time.

Algernon, 4th Duke of Northumberland (1792–1865), was Patron of the Society of Antiquaries of Newcastle and became a strong supporter of Bruce's work. The duke's archaeological advisor was Albert Way (1805–1874), friend to Charles Darwin, the grandson of a MP and well connected through marriage to important political families. Way had helped found the Royal Archaeological Institute in 1844 and was the director of the Society of Antiquaries of London for several years.

OPPOSITE. John Collingwood Bruce

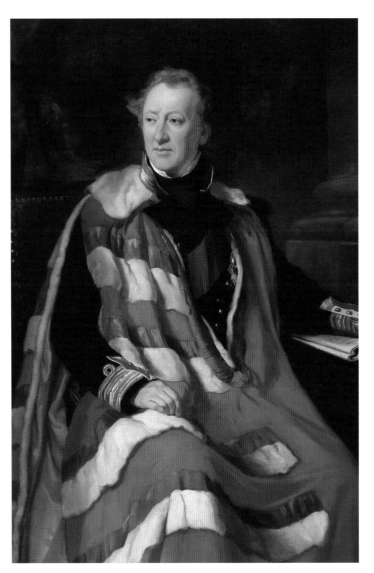

Bruce, as we have seen, began his serious study of Hadrian's Wall in 1848 at the age of 42, having visited it as a schoolboy, student and young man. The publication of *The Roman Wall* in 1851 brought him into closer contact not only with the duke, but also with the wider archaeological fraternity including Albert Way and Charles Roach Smith (1807–1890), a well-known antiquarian and numismatist. In 1852, Bruce was elected a Fellow of the Society of Antiquaries of London. In the same year he was called upon by the duke to offer advice on his excavations at the Roman fort at High Rochester, and Bruce took it upon himself to publish the results (Bruce 1857; the excavation was recorded by Henry Richardson).

Reading between the lines of Gainsford Bruce's (1905) biography of his father, it is possible that many of the proposals for action put to Bruce by the duke emanated from Albert Way, and this is confirmed by an unpublished letter of 27 November 1849 from the duke to Bruce.

Bruce's achievement was to recognise the good ideas and follow them up. He supported Way's proposal that the duke sponsor a survey of Hadrian's Wall – undertaken by Henry MacLauchlan in the 1850s (Bruce was to use these maps in the later editions of his books). The duke – or was it Albert Way? – had the idea in 1855 to publish all the

LEFT. Algernon, 4th Duke of Northumberland

6

Roman inscriptions in Northumberland and suggested that Bruce undertake the work, which he did, publishing *Lapidarium Septentrionale* in 1875. Bruce may not have had all the best ideas, but he had the energy to carry them out. He was also a great communicator, which is not surprising considering that he was both a minister of the church and a schoolteacher. Sometimes his keenness to communicate new information to his public landed him in trouble. He could be cavalier with his sources, not acknowledging his debt to earlier writers (as was pointed out in reviews) and failing to acknowledge the information which Glasford Potter had provided on his excavations at Birdoswald in 1850 prior to publication (Miket 1984). To be fair to Bruce, at this stage of his career he was still learning the correct academic style of citation of sources; his previous publications had been school textbooks and guidebooks in which such rigorous acknowledgments were not necessary.

Bruce's publications in the first half of the 1850s – and his robust challenges to critics – made his dominance of mural studies unchallengeable. For the next forty years Bruce was 'king of the Wall'. But archaeological research does not stop and by the time he was in his eighties some saw him as an impediment to progress. R. S. Ferguson remarked that there 'were "young bloods" at Newcastle only waiting till Dr Bruce died to awake the slumbering problems of the Wall' (Neilson 1912, 39). Bruce died in 1892 and

Albert Way

7

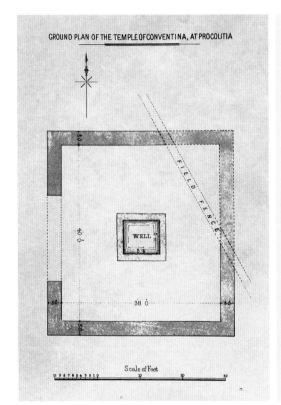

Plan of Coventina's Well excavated by Bruce

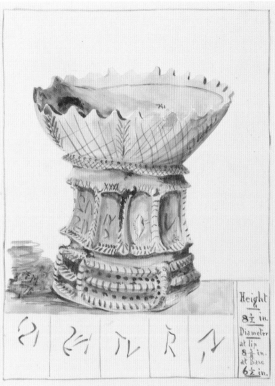
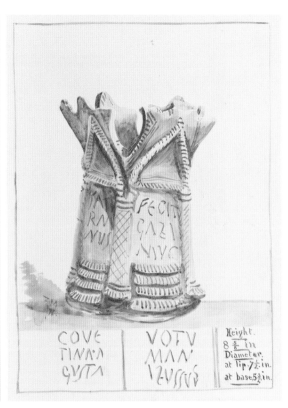

Two ornate vessels found in Coventina's Well, probably painted by Thomas Miles Richardson junior

there did indeed follow a flurry of new activity on the Wall, including J. P. Gibson's excavation of Mucklebank turret in 1892 and the beginning of Francis Haverfield's ten-year long campaign of excavations on the earthworks of the Wall (Breeze 2014).

Bruce died weighed down with honours and described as one of Newcastle's most illustrious sons (Bruce 1905, 383–4). At his funeral, the carriages, when lined up, occupied nearly the whole length of Jesmond Road from the Hancock Museum to Jesmond Old Cemetery, and the

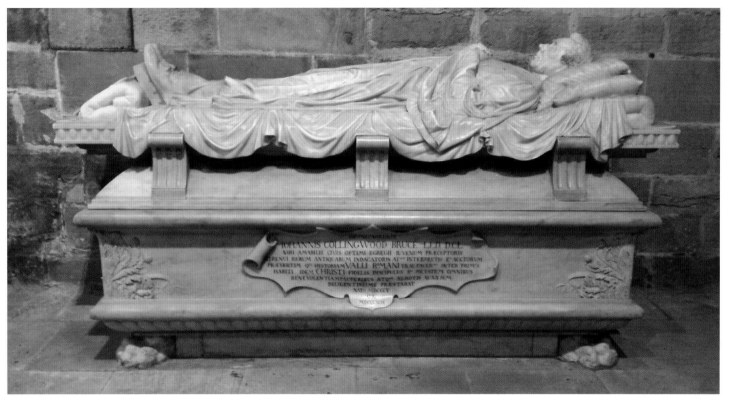

The memorial to Bruce in St Nicholas Cathedral

procession, passing through pavements lined with people, was attended by the Mayor and Sheriff of the city; the Duke of Northumberland sent his apologies. It was met at the gates of the cemetery by the ladies of the Infirmary Singing Band intoning 'I am the Resurrection and the Life'. The sermon was preached outside to a vast throng. Four years later, a memorial was unveiled by the Earl of Ravensworth in the Cathedral Church of St Nicholas in Newcastle: not bad for a Presbyterian Minister – and an archaeologist.

9

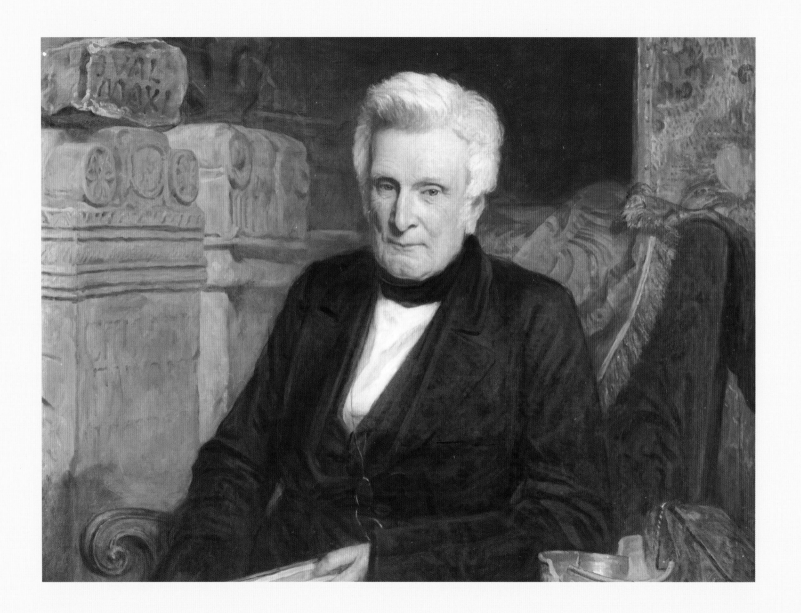

John Clayton

Nathaniel Clayton bought the Chesters estate at Chollerford in 1796. He was a lawyer with a practice in London as well as in Newcastle and served as Town Clerk to Newcastle from 1785 to 1822. His town house was Westgate House in Fenkle Street, beside Hadrian's Wall, and it is here that his third son, John, was born on 10 June 1792.

Several of Nathaniel's sons followed him into the law. In 1809 he took John into his practice. In 1815 John qualified as an attorney and in time became the senior partner in the firm, succeeding his father in 1822 as Town Clerk and holding that office for forty-five years. He became a very wealthy man.

Clayton used his wealth to buy farms along Hadrian's Wall and excavate the Roman remains using a small team of skilled workmen. He bought four farms in 1834 including Hotbank and Steel Rigg in the stretch west of Housesteads. Housesteads itself was acquired in 1838, but it was not until 1849 or 1850 that Clayton set about disinterring the walls and gates of the fort, perhaps stimulated by the visit of the Pilgrimage in 1849; several of his excavations appear to have followed visits by other antiquarians.

Clayton started work at Chesters in 1843 and examined MC 42 (Cawfields) in 1847 following his purchase of the farm in 1844. He moved on to MC 39 (Castle Nick) in 1854, Chesters bridge abutment in the early 1860s, and T 29a (Blackcarts) in 1873, all featured in this book. Clayton examined other sites, including the fort bath-house and Coventina's Well at Carrawburgh as well as his own fort at Chesters. He was in his eighties when he investigated the bath-house at Chesters and at the same time he bought Carvoran fort and started excavating there!

OPPOSITE. John Clayton

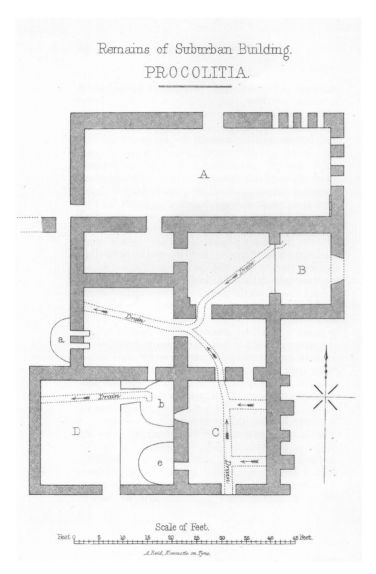

Remains of Suburban Building.

PROCOLITIA.

Scale of Feet.

Feet 0 5 10 15 20 25 30 35 40 45 Feet.

A. Reid, Newcastle on Tyne.

Clayton had an unusual approach to the conservation of Hadrian's Wall. He had his men replace fallen stones to create the Wall that we see today. When the Wall was consolidated by the Ministry of Works in the middle years of the twentieth century, these stones were back-pointed to indicate that they had been replaced by Clayton's workmen. Clayton's actions were a useful conservation measure and had the advantage of protecting the genuine Roman masonry and mortar. Clayton's careful approach to the Wall did not extend to all of his other archaeological activities. After his examination of the bath-house at Carrawburgh, for example, he allowed his tenants to remove the stones, and in spite of producing a creditable plan, he did not record the exact location of the building.

John Clayton died in 1890 at the age of 98, owning five forts (Chesters, Carrawburgh, Housesteads, Carvoran and Chesterholm/Vindolanda) as well as most of the 15 miles (24 km) length of the Wall itself from the North Tyne westwards to Cawfields. His heirs created the museum which still stands at Chesters to house the artefacts that were accumulated during his excavations. The estate was broken up and sold in 1929.

In his earlier years, Clayton wrote his own excavation reports. In the manner of the day, these took the form of a

LEFT. Plan of the bath-house at Carrawburgh excavated by Clayton in 1874

letter to the secretary of the Society of Antiquaries of Newcastle, which he had joined in 1832 (his father was a founder member); the letters were then published in *Archaeologia Aeliana*, the journal of the Society. Clayton continued publishing reports into his nineties, contributing a total of twenty to *Archaeologia Aeliana*. Surprisingly, however, in later years he left some of the reporting of the work at Chesters – visible from his own front windows – to Bruce, who would regularly visit the site to record work in progress. The relationship between the two men is demonstrated by Bruce dedicating each edition of *The Roman Wall* to John Clayton.

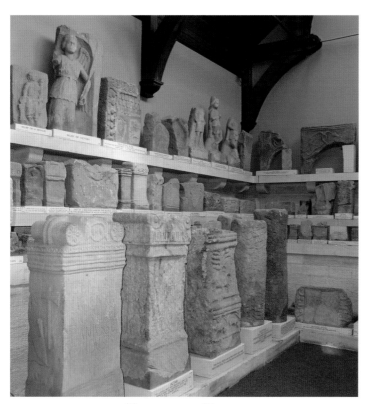

The museum at Chesters

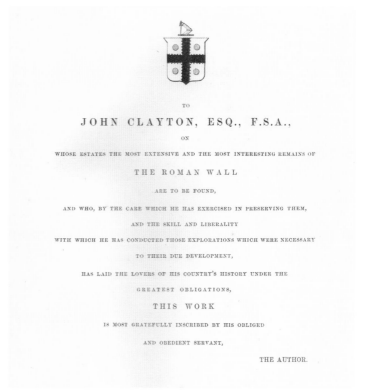

TO

JOHN CLAYTON, ESQ., F.S.A.,

ON

WHOSE ESTATES THE MOST EXTENSIVE AND THE MOST INTERESTING REMAINS OF

THE ROMAN WALL

ARE TO BE FOUND,

AND WHO, BY THE CARE WHICH HE HAS EXERCISED IN PRESERVING THEM,

AND THE SKILL AND LIBERALITY

WITH WHICH HE HAS CONDUCTED THOSE EXPLORATIONS WHICH WERE NECESSARY

TO THEIR DUE DEVELOPMENT,

HAS LAID THE LOVERS OF HIS COUNTRY'S HISTORY UNDER THE

GREATEST OBLIGATIONS,

THIS WORK

IS MOST GRATEFULLY INSCRIBED BY HIS OBLIGED

AND OBEDIENT SERVANT,

THE AUTHOR.

The dedication in *The Roman Wall*

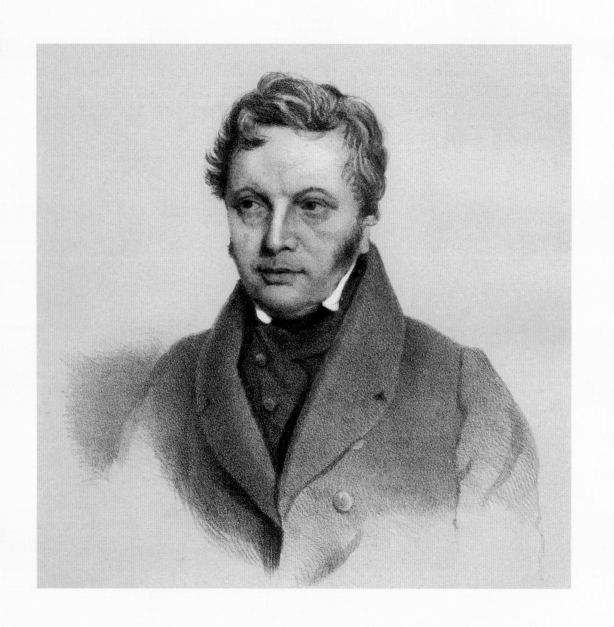

The Richardson family

This Newcastle family were a talented group of painters. Thomas Miles Richardson (1784–1848), like his father, headmaster of St Andrews School, was best known for his oil paintings and watercolours of northern scenery; he was a co-founder of the Northern Society of Painters in Water Colours. He married twice and had six sons, all painters. Henry Burdon (1826–1874) was the first son of his second marriage and was the most prolific painter of Hadrian's Wall; he is the main subject of this book. His elder half-brother, Thomas Miles junior (1813–1890), also painted the Wall, as did Charles (1829–1908), who created several watercolours of the bath-house at Chesters, and their cousin George Bouchier Richardson (1822–1877).

The only known depiction of the Wall by Thomas Miles Richardson senior, dating to 1823, is of the two short stretches at East Denton (Brewis 1927, fig. 2., opposite p. 120; plate 7 below). The first known painting by his son and namesake, Thomas Miles junior, is of Housesteads and dates to about 1850. He also produced an artist's impression of the burial ground at Chesters and created a beautiful view of Crag Lough.

Charles Richardson painted a view of Wallsend looking down the Tyne which was used in *The Roman Wall* and in *Views* as well as several of the commander's house and the bath-house at Chesters, uncovered in the 1880s.

George Bouchier Richardson was educated at Bruce's school and joined the Society of Antiquaries of Newcastle in 1848 (*Archaeologia Aeliana* 3rd ser., 10 (1913) 222–4). He was in that illustrious company that made the first Pilgrimage of Hadrian's Wall in 1849. George was printer to the Society of Antiquaries and printed the first and second editions of *The Roman Wall* (1851 and 1853). He was also

OPPOSITE. Thomas Miles Richardson senior

15

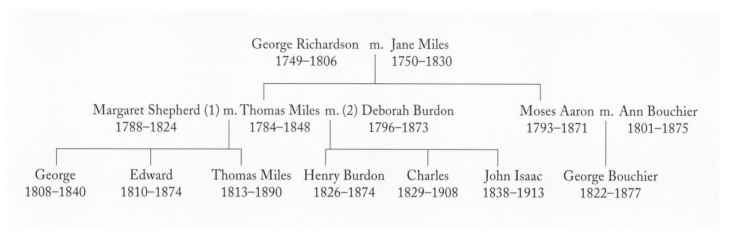

George Richardson m. Jane Miles
1749–1806 | 1750–1830

Margaret Shepherd (1) m. Thomas Miles m. (2) Deborah Burdon
1788–1824 | 1784–1848 | 1796–1873

Moses Aaron m. Ann Bouchier
1793–1871 | 1801–1875

George
1808–1840

Edward
1810–1874

Thomas Miles
1813–1890

Henry Burdon
1826–1874

Charles
1829–1908

John Isaac
1838–1913

George Bouchier
1822–1877

The Richardsons: a select family tree

interested in archaeology, recording information on the line of the Wall in Newcastle, the location of the fort and the discovery of artefacts (Richardson 1855), as well as creating the artist's impression of Roman Newcastle which is reproduced in this book. He emigrated to Melbourne in 1854, there joining his father, Moses Aaron Richardson (1793–1871), a publisher and bookseller, and his brother John Thomas (1835–1898), also an artist.

Most of the paintings of Hadrian's Wall by the family, at least 77 in total, were by Henry Burdon Richardson. While the majority were painted in 1848, some are of features not excavated until later, such as MC 39 (Castle Nick), which was investigated in 1853, Chesters bridge

abutment, examined in the 1860s, and Blackcarts turret, excavated in 1873, the year before his death.

Unlike his brothers Thomas Miles and Charles, who moved south, Henry continued to live in Newcastle. In 1850 he announced that he gave 'Lessons in Landscape and Marine Painting, either at his own house [20 Ridley Place] or at the home of pupils'. His brother, Charles, living at the same address at that time had classes in drawing. The 1871 census records that Henry was still living on Ridley Place three years before his death; his occupation was 'artist'. In that census, and in 1881, Charles was described as 'artist landscape painter'. In 1881 he was living in Hastings, though he returned to the north to record the newly

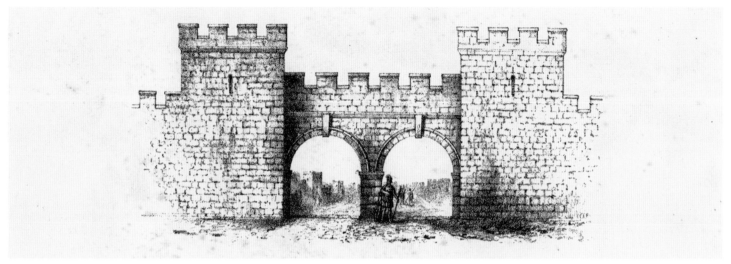

An impression of Birdoswald east gate by John Storey

discovered remains at Chesters. He subsequently moved to London and thence to Peterborough where he died in 1908, as did his younger brother John Isaac in 1913.

One of the pupils of Thomas Miles Richardson senior was John Storey (1828–1888). Storey specialised in topographical and architectural drawing, and Bruce used many of his engravings. These included *Wallsend, Looking East* (Bruce 1851, facing p. 115), *Written Rock in the River Gelt* (Bruce 1851, facing p. 81; *Views*), and *The Crags, West of Crag Lough* (Bruce 1851, facing p. 243; *Views*). Storey also drew many of the images used as woodcuts in the various editions of *The Roman Wall*. Henry Glasford Potter, and

his brother William, employed him to produce the illustrations of their discoveries at Birdoswald, including a reconstruction of the east gate (Potter 1855, 63, 69, 141).

Another contemporary local painter was David Mossman (1825–1901). He painted watercolours of Chesters bridge abutment (Bidwell and Holbrook 1989), T 29a (Blackcarts), MC 42 (Cawfields) and the Wall crossing the Nine Nicks of Thirlwall. Bruce noted that Mossman accompanied him along the Wall in 1865 during his preparatory work for the third edition of *The Roman Wall* and that he recorded the excavations at Chesters in 1869 (Bruce 1905, 153, 155).

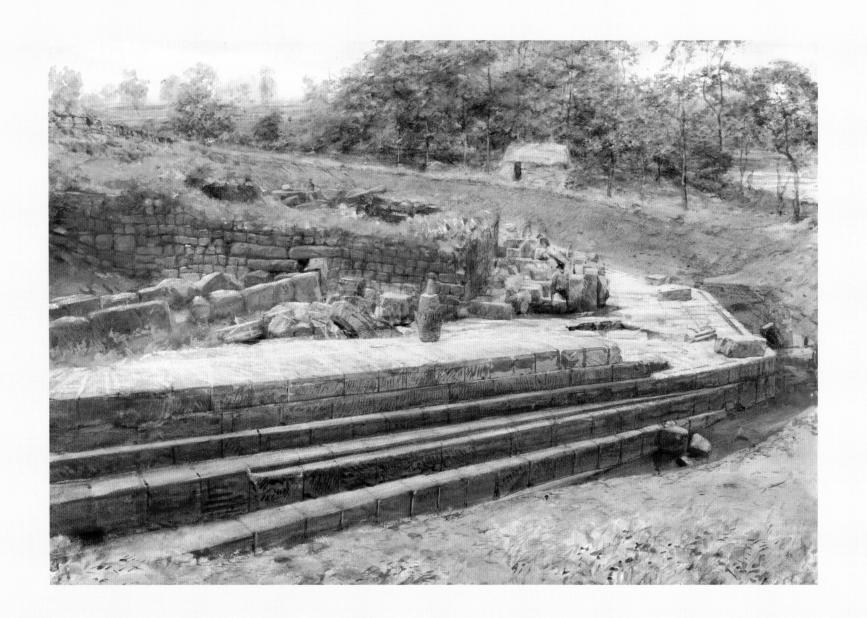

The paintings and engravings

Henry Richardson created about forty-eight paintings of Hadrian's Wall in 1848 and later a further eleven paintings or drawings (in addition, he painted Barcombe Hill, Bewcastle and High Rochester). These form by a significant margin the single largest contribution of the Richardson family to the record of the frontier. Bruce used just twenty-seven of the paintings prepared in 1848 in any of his publications. He preferred the detailed paintings of the monument and rarely included a landscape view.

Richardson returned to Hadrian's Wall after 1848 to paint new discoveries. These included the north and west gates at Housesteads and Housesteads milecastle (MC 37) investigated by Clayton in the early 1850s, Chesters bridge abutment cleared in the early 1860s, the east gate at Chesters excavated in 1867 and Blackcarts turret (T 29a) examined in 1873; Henry Richardson died the following year.

Only twenty-two of Richardson's paintings were turned into engravings for Bruce's *The Roman Wall*, with another five used as the basis for woodcuts, though some with the physical features exaggerated in the style of the period (two of Charles's paintings were turned into engravings and one into a woodcut). Most of the engravings were prepared by John Storey, others by J. S. Kell of Holburn, London, while Newbald and Stead of York created engravings of new subjects for use in the third edition of *The Roman Wall*, even when the drawing had been prepared by Storey.

The very act of creating the engravings introduced minor differences from the paintings, not least because the lines had to be sharper; this particularly affected the depiction of the foliage. Sometimes figures were moved, removed or even added. There is also a difference between the engravers. Engravings by Kell tend to be true to the

OPPOSITE. Chesters bridge abutment by Henry Burdon Richardson

paintings: for example, the west gate of Housesteads and MC 37 (Housesteads). On the other hand, the viewpoint of the engraving of MC 39 (Castle Nick) is slightly different from that of the painting.

The engravings prepared by John Storey are a different matter. Although many are exactly the same viewpoint, some show significant differences from Richardson's original paintings. The angle of the view is slightly moved at MC 42 (Cawfields), but equally significantly the engraving shows the whole of the wall to the west of the milecastle cleared of debris and visible unlike in the Richardson painting. We are specifically informed that the original sketch was prepared during the excavation so there must have been a subsequent visit in order to create the engraving. At Housesteads the change is to the drawing of the east gate. The angle of the view in the engraving is slightly different, while there are modifications to the wall blocking the south portal and the threshold stones in the north portal, as well as other details. There are also differences between the painting of Steel Rigg and the published engraving, which is undertaken from a different angle.

Who made these changes? The obvious conclusion is that Bruce selected the paintings he wanted to have turned into engravings for his 1851 publications and commissioned Storey to undertake the work. This is the process recorded by Bruce some years later in relation to the view of Byker when he described sending Storey into the field to update Stukeley's sketch of 1776 (Bruce 1867, 96). Storey then visited the sites and redrew the views. We can even date Storey's visit to Birdoswald. The excavation of the minor west gate here was undertaken in September 1850 while it is recorded that Bruce was completing his book in the 'last days of the year 1850', so we have a small window available for Storey's visit (Potter 1855, 63; Bruce 1905, 126). What Richardson thought of this process we cannot know.

Some paintings and engravings record the clearance of sites in progress but otherwise in none of these images are the differences of any great significance; all appear to be true to what was visible. One later sketch is a different matter. This is T 29a (Blackcarts), excavated by Clayton in 1873. It is clear that the engraving published in the excavation report (Clayton 1876b) was based on the painting of the turret by David Mossman in 1875 as the engraving is a faithful representation of the painting. Henry Richardson also sketched the turret, but his image is significantly different from the Mossman painting. The western point of reduction is different as are the courses in the internal north-east angle. The vegetation is also different. Mossman has one large tree immediately to the east of the turret, Richardson two small trees. To the west, Mossman has two trees, Richardson only one, with a branch protruding above the back wall of the turret. But which is correct?

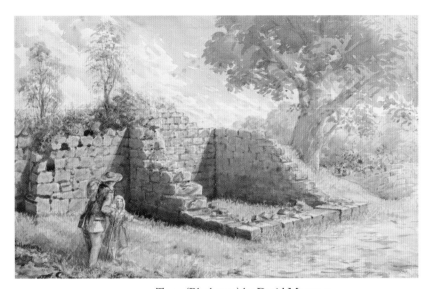

T 29a (Blackcarts) by David Mossman

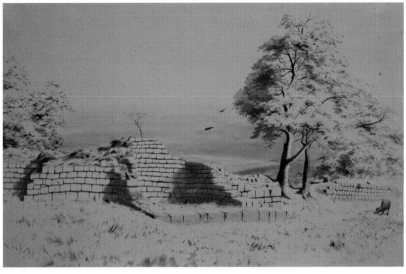

T 29a (Blackcarts) by Henry Richardson

Perhaps Mossman's depiction as his was the version used by Bruce.

Modifications when a painting was turned into an engraving are not unique to Henry Richardson's work. Paul Bidwell has noted that a painting of the culvert on the Sugley Burn, unsigned but in the style of David Mossman, was changed in several details, thereby giving a wrong impression of the relationship between the culvert and the wall (Bidwell 1997).

Richardson's later paintings can be recognised as a result of their attention to detail, which had not been possible in the concentrated activity of 1848. As Richardson did not date his paintings, it is not always possible to determine when some were painted.

In spite of the debt which he owed to Henry Richardson, Bruce was sparing with his thanks. Richardson's paintings were used as engravings or woodcuts in all three editions of *The Roman Wall* and in *Views*, while some smaller versions were included in editions of his *Hand-book to the Roman Wall*. Richardson, however, is not thanked in the preface of any of these publications, and in some editions his name is omitted from the illustration (only

eleven of the nineteen full-page reproductions in the 1851 edition are acknowledged to Richardson, and Bruce was even more remiss in the 1867 edition). Perhaps Bruce simply saw Richardson as his employee and therefore not requiring acknowledgment. By way of contrast, in the preface to the second edition of *The Hand-book to the Roman Wall* Bruce did acknowledge his debt 'to the artistic skill and kindness of his friend Mr. C. J. Spence' in preparing 'several plates depicting various scenes met with on the Wall' (Bruce 1884, iv). But, as we have seen, Bruce was cavalier in his acknowledgement of the work of others.

Few reviewers of *The Roman Wall* mentioned the illustrations. *Tait's Edinburgh Magazine* for March 1851 commented that 'the pictorial illustrations to the work are carefully executed', but it is not surprising that the most fulsome praise was in the *Journal of the Belles Lettres* (26 April 1851), 'the volume is illustrated by skilfully-drawn lithographs of views on the line of wall, which will interest others beside the antiquary', with criticism reserved for the woodcuts, which were described as heavy and too dense. Following the publication of the second edition, the reviewer in the *Newcastle Courant* (17 December 1852) wrote, 'the numerous and admirably-executed lithographic plates are the work of Mr John Storey, jun., from drawings by himself, Messrs G. B., E. B. and H. Richardson, and Mr Sopwith': acknowledgement at last.

The afterlife of the paintings

The Richardson paintings remained in the ownership of John Collingwood Bruce. He continued to use them to illustrate his lectures. The Minute Book of the Cambridge Antiquarian Society records that his lecture to that body on 27 February 1882, when he was elected an honorary member, was 'fully illustrated by a series of water-colour drawings'; these were presumably Richardson's 1848 paintings. In October 1883 Bruce delivered the Rhind lectures to the Society of Antiquaries of Scotland in Edinburgh and again we may presume that he used Richardson's paintings, thirty-five years after they were created.

The faded nature of many of the paintings – the blue has almost disappeared from the sky, for example – indicates that they were hung on the walls of Bruce's house. They were listed in a notebook entitled *Drawings of Portions of the Roman Wall in the possession of J. Collingwood Bruce LL.D. 2 Framlington Place Newcastle upon Tyne 1886*, which was donated to the Laing Art Gallery, presumably with the paintings. The list was later published in an undated pamphlet entitled *Drawings of the Roman Wall, with a description by the late J. Collingwood Bruce LLD, DCL, FSA*.

Bruce died in 1892. His son, Gainsford Bruce, gave Henry Richardson's paintings, together with others by Charles Richardson, Peter Toft and Alfred Wilkinson, to the Laing Art Gallery in Newcastle upon Tyne. In 1906, the gallery held an exhibition of forty of the paintings.

The catalogue accompanying the exhibition described the preparation of the paintings. 'Most of the drawings were in the first instance executed on the spot in sepia, as a rapid means of effectually delineating the features of the Wall, and of the country through which it passed. The artist (Henry Burdon Richardson) afterwards added slight washes of colour to the sketches, and this was carried out so skilfully that they have the appearance of completed drawings in colour.' The 'drawings are remarkable for their

combination of realistic truth and artistic charm . . ., are conspicuous by their originality and careful realism, and have a simple beauty of their own'.

The quotations at the beginning of most entries in this book are taken from the 1886 notebook. They are almost the same as the entries in the 1906 catalogue, in which some words such as 'fosse', that is ditch, were slightly modernised.

Various archaeologists have returned to the paintings to show the state of Hadrian's Wall in 1848. Those covering the eastern end of the Wall from Wallsend to Denton were included within the report on *The Roman Frontier from Wallsend to Rudchester Burn*, but in black-and-white (Spain *et al.* 1930). Those of Chesters bridge abutment and Harrow's Scar were published, in colour, in *Hadrian's Wall Bridges*, together with some of Mossman's paintings (Bidwell and Holbrook 1989). Elsewhere, it has been usually the engravings that have been reproduced.

One entirely different type of change may be noted since 1848, which is to the names of some of the sectors of Hadrian's Wall. The place-name Tepper Moor has tended to be replaced by Limestone Corner; Tower Tay is now Tower Tye, Rutchester has become Rudchester.

Hadrian's Wall in 1848

It may seem strange that the people of Newcastle knew so little about Hadrian's Wall in 1848. But perhaps not. Travel was more difficult; Bruce and his son explored the Wall by pony or horse-drawn carriage, but then his affluent household included not only two live-in servants but also a groom. The Carlisle–Newcastle railway reached the centre of Newcastle in 1847, but the Central Station was not fully open until 1851. Indeed Bruce wrote his books at a propitious moment as travel in the region was becoming easier. And yet his guidebooks to Hadrian's Wall were not the first to have been published: John Warburton published his *Vallum Romanum* (with its snappy subtitle: *or The History and Antiquities of the Roman Wall, commonly called the Picts Wall, in Cumberland and Northumberland, Built by Hadrian and Severus . . . in Three Books*) in 1753.

The central sector of Hadrian's Wall was remote and wild, largely devoid of trees and difficult to access. Farms were isolated, hotels and inns almost non-existent. In 1801,

William Hutton described the central sector thus; 'a country thinly inhabited, surrounded with commons, or with enclosures of fifty or a hundred acres each, but without trees or hedges, and where the face of the earth seems shaved to the quick' (Hutton 1802, 213). Many of Richardson's paintings are remarkable for the lack of buildings featured in them, and indeed many of these views are little different today. One significant change is actually the removal of some farms which appear in the paintings, for example, of Shield-on-the-Wall and Housesteads. John Clayton later demolished these buildings and erected new farms for his tenants elsewhere, often in a neo-Tudor style (Woodside and Crow 1999, 122).

The Wall had been used as a convenient quarry by local people for centuries, building their churches, castles, houses and field walls of Roman stones. But in 1848 a surprising amount of stonework was visible as also demonstrated by the few surviving earlier illustrations, while the earthworks

of the Wall were better preserved than today (Hingley 2012). Henry Richardson's paintings are particularly valuable because there are so many of them, covering the whole length of the Wall and offering a snapshot in time and a record of the state of the surviving remains at that date.

Several views are particularly important for they depict sections of the Wall which have since disappeared. The expansion of Tyneside from Wallsend to Heddon-on-the-Wall was the largest threat to the Wall, which disappeared under houses and factories, roads and railways, and even a reservoir at Benwell; Bruce recorded these depredations in his books on the Wall. Quarrying resulted in bites cut out of the landscape at Cawfields and Walltown, but also at Elswick on the western fringes of Newcastle. As a portfolio, they are unique, with only the less sophisticated pen and ink drawings by James Irwin Coates, dating to later in the nineteenth century, as a comparison for size and extent (Whitworth 2012). Mention should also be made of a smaller group of watercolour paintings and sketches of the Walltown area by an anonymous artist dating to 1851 (Breeze 2015).

In 1848, archaeological investigations of Hadrian's Wall through excavation had hardly begun. The Rev. Anthony Hedley examined Chesterholm/Vindolanda between 1818 and his death in 1835. His contemporary, the Rev. John Hodgson, excavated at Housesteads from 1822 until 1833 (Birley 1961, 59–60, 180). A major step forward came in the following decade when John Clayton started examining the Wall. Henry Richardson's painting of MC 42 (Cawfields) while it was being excavated in 1848 is a harbinger of the many actions of archaeologists during the decades to come.

Bruce's six editions of *The Roman Wall* and its offshoot *The Hand-book to the Roman Wall* form a valuable record of Hadrian's Wall at the time of the 1848 expedition and its vicissitudes over the following thirty-seven years, as well, of course, as recording his own increasing knowledge of the frontier (Bruce 1851, 1853, 1863, 1867, 1884, 1885).

Hadrian's Wall today

Understanding of Hadrian's Wall was just entering the modern age in 1848. The essential components of the frontier were recognised: the Wall itself running across the country from Wallsend to Bowness-on-Solway, with forts, milecastles and turrets along its line linked by a road, the Military Way, and with the Vallum behind. But the relationships between the various elements were not understood (Breeze 2014). It was only in 1840 that John Hodgson concluded that the Wall had been built by the Emperor Hadrian in the 120s and not by the Emperor Septimius Severus nearly a hundred years later. The main reason for this misattribution was simply because most of the ancient sources stated that Severus built the Wall and they had been believed for centuries. Antiquarians were of the view that Hadrian's contribution to the frontier works was the Vallum, then seen as a precursor of Severus's Wall. Although Bruce accepted Hodgson's proposition, others did not and the argument would rumble on until the end of the century. Hodgson had also firmly stated that the Wall, the Vallum and the forts were all part of one scheme, and this again was accepted by Bruce.

In 1847, a northern gate to a milecastle (MC 42 at Cawfields) was discovered, completely changing perceptions of the relationship between the Romans and their neighbours. Turrets were known, but it would be another thirty-three years before the spacing between them was understood. The method by which these mysteries would be unravelled, namely through archaeological excavation, was in its infancy, and it would be another fifty years before it can be said to have grown up. Another great aid to understanding Hadrian's Wall were decent plans and maps, but the maps on which scholars had to depend had all been prepared in the previous century, including those used by Bruce in his early books; it was not until the 1850s that Henry MacLauchlan undertook his magnificent survey of the Wall.

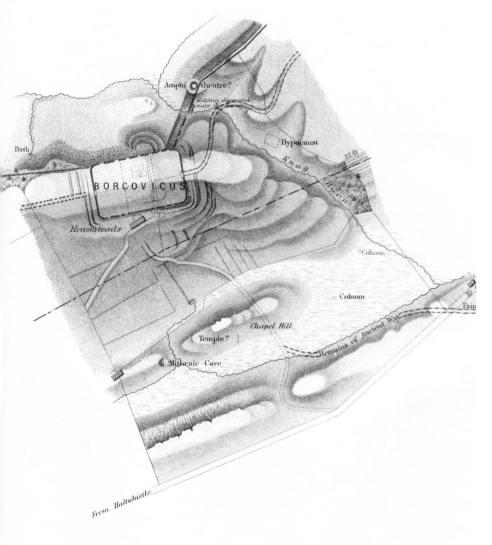

We have certainly moved on since 1848, but by no means have all of the problems of Hadrian's Wall been solved, and indeed much of its mystery remains. We agree that the Wall was built by Hadrian, and that it was built in two stages. The original plan was for a linear barrier 80 Roman miles (130 km) long from Wallsend to Bowness-on-Solway, the eastern part to be built in stone and the western in turf, with a ditch in front except where the crags or the Solway made it unnecessary. A milecastle, each containing a gate through the Wall and a small building, was placed at every mile with two turrets in between. Work on this started in about 122. It was placed to the north of an existing line of forts which stretched from Corbridge on the river Tyne to Carlisle and thence to Kirkbride. Before this plan was completed, it was decided to add thirteen forts to the Wall line. Wherever local topography allowed, these were placed astride the wall in an arrangement unique within the Roman Empire. The reason was probably to aid troop mobility in the frontier zone. The implementation of this new plan will have created more work for the army – and it was the Roman army which built Hadrian's Wall; Clayton collected many of the building stones that demonstrate this. It is probably the increasing scale of the building programme that led to changes, a reduction in the width

LEFT. MacLauchlan's survey of Housesteads

of the wall from 10 Roman feet (the Broad Wall) to 8 feet or less (the Narrow Wall) and a reduction in the standard of workmanship.

The Vallum is a great earthwork running behind the Wall. It consisted of a central ditch with a mound set back on each side. It deviated round the forts so it was presumably later than them. It restricted access to the frontier zone, which was now only possible at a fort where there was an undug causeway of earth, apparently surmounted by a gate. In places, the Vallum shows evidence of being slighted, with gaps cut in the mounds and material dumped in the ditch to form crossings. It is assumed that these events related to the abandonment of Hadrian's Wall when the Antonine Wall was constructed in the early 140s when, also, the gates were removed from the milecastles thereby allowing free movement across the Wall. Later, some of the crossings were removed and it was presumably at this time that the original purpose of the Vallum was restored by the creation of a marginal mound on the southern lip of the ditch to cut off access to the remaining crossings. These events probably occurred when the Antonine Wall was abandoned and the army returned to repair and reoccupy Hadrian's Wall in 158 or soon after. It was at this time, or shortly afterwards, that a road, the Military Way, was constructed along the Wall.

Although the Wall was re-commissioned in the same form as before, changes soon occurred. Some turrets were abandoned, milecastle north gates were narrowed, settlements grew up outside forts, and buildings were allowed to spread over the infilled Vallum ditch. These extramural settlements lasted for a little over a hundred years when some appear to have been abandoned. Changes also occurred within forts, with amendments to buildings and the complete reconstruction of others.

Warfare occasionally afflicted the soldiers of the Wall. The ancient historian Cassius Dio recorded that, in the early 180s, 'the northern tribes crossed the wall that divided them from the Roman forts and killed a general and the troops that he had with him' (Cassius Dio, *History of Rome* 77, 8, 2). The third century seems to have been quiet on the northern frontier, but the rise of the Picts, first recorded in 297, was a harbinger of trouble. There were several invasions in the second half of the fourth century by the Picts from north of the Wall and the Scots who lived in Ireland. It was not these peoples who brought an end to Hadrian's Wall, however, but collapse of power at the centre of the empire. On the last day of 406 the river Rhine was crossed by a strong force of Alans, Suebi and Vandals which swept across Gaul. Rome itself fell in 410 to Alaric and his Goths. The soldiers of the Wall may have continued to protect Britain for some years, but slowly life on the frontier came to an end.

The painter, his patron
and his patron's patron

There is an interesting social commentary behind the paintings. Society in the reign of Queen Victoria was more hierarchical than today. The social status of the heroes of 1848 is revealed by the censuses and their wills. At the top of the social pyramid was the Duke of Northumberland, financial sponsor of Henry MacLauchlan's survey of the Wall and the Roman roads of north-east England, and of the excavations at High Rochester, all in the 1850s. He lived in Alnwick Castle, which he extensively re-modelled, but he also had vast estates elsewhere. In 1851 he had a staff of twenty servants at just one of his several houses. He served briefly as First Lord of the Admiralty in 1852.

John Clayton was a successful lawyer and entrepreneur, inheritor of a country estate, Chesters, through which Hadrian's Wall runs. The 1881 census records that there were twelve servants at Chesters; he left £728,746 in his will,

about £70 million in today's money. He owned not only Chesters and many miles of Hadrian's Wall, but land, houses and warehouses in five other counties including London, two law firms, one in Newcastle and the other in London, and a town house in Newcastle.

John Collingwood Bruce had just one house in Newcastle, only three servants, one of whom was the groom, and left £17,269 in his will, or about £1.7 million at today's prices.

Henry Burdon Richardson lived in rented accommodation (which was not uncommon in the nineteenth century) apparently usually with no live-in servants, except in 1861 when one maid served the needs of the family of five. He left a little less than £800, about £80,000 in today's terms.

Henry MacLauchlan fared rather better. His will was proved at £4,166 following his death in 1882 aged 89.

OPPOSITE. Bruce's house, 2 Framlington Place

31

THE
PAINTINGS

Wallsend looking west
Henry Burdon Richardson

'The gentle mound on the right of the sketch is the south-east angle of the station of SEGEDUNUM, *Wallsend. Water occupies the fosse [ditch] outside the eastern rampart. The river Tyne is seen stretching towards Newcastle.'*

Bruce did not use this painting. By his day little visible remained of this fort, which lay at the eastern end of the Wall. The northern rampart had gone and the southern ramparts reduced to 'a grassy mound' (Bruce 1851, 114). The continuation of the Wall down to the river, however, was still visible, not only as a mound but with stones and mortar sticking out from it. By 1884 only the eastern rampart, south-east corner and ditch were visible (Bruce 1884, 37).

The fort was excavated in the 1970s and 1980s and most of it is now on display in the archaeological park of Segedunum, which includes a museum, a reconstruction of a stretch of Hadrian's Wall and a replica Roman bath-house based on that at Chesters.

References: *Drawings* No. 1.
Laing G3852.

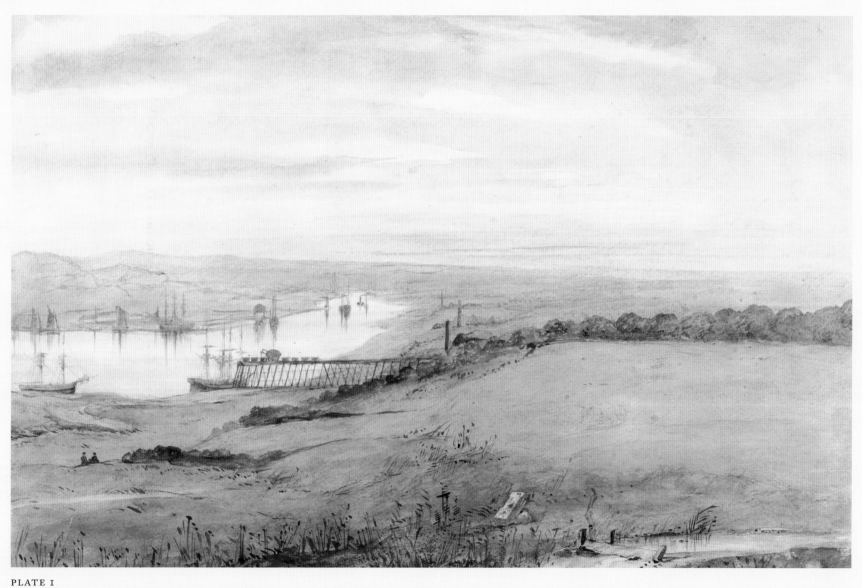

PLATE I

Wallsend looking east

Charles Richardson

'A coloured drawing taken from the S.E. rampart of the station at Wallsend and commanding a view of the river as it was in 1848; looking towards Jarrow and the estuary of the Tyne.'

This view by Charles Richardson is looking eastwards, that is, down river towards the estuary, the opposite direction from his brother. It shows the southern rampart of the fort overlooking the river. Bruce used this version by Charles though it is labelled 'Drawn & Lithographed by John Storey', whereas Henry was usually acknowledged even though the view had been redrawn by Storey.

Charles Richardson also produced 'A sepia drawing of the view from the S.E. rampart of Wallsend; the original of No. 58' (*Drawings* 71). For discussion of the three paintings of Wallsend see Bidwell (2015).

References: Bruce 1851, facing p. 115; Bruce 1853, facing p. 90; Bruce 1867, facing p. 90; *Views*; *Drawings* Nos 71 (sepia) and 58 (coloured); both appear to be lost.

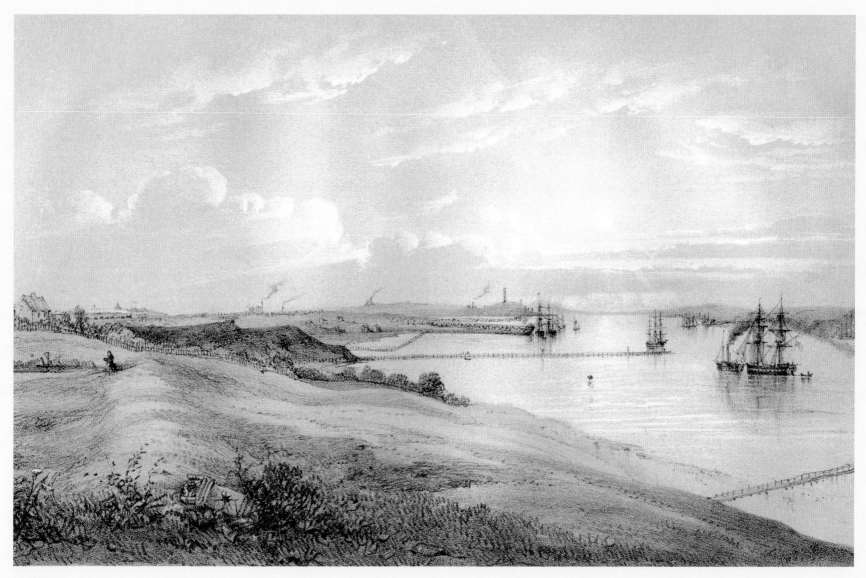

PLATE 2

Stote's Houses

Henry Burdon Richardson

An unlabelled painting by Charles Richardson shows many similarities with Henry's view, though there are differences, in particular in relation to the house. The simpler house may indicate that this was painted before his brother's view.

'"*Stote's Houses," the "Bee Houses" of Horsley. A duck pond on the right occupies the north fosse [ditch] of the Wall. The Wall has run up right from this point to Byker, and has left traces of its course in the colour of the vegetation.*'

'In front of Stote's-houses, the Beehouses of Horsley, it [the ditch] forms a pond, which is used for farm purposes. Some traces of the foundations of the Wall may be seen, but they are faint. Thirty years ago the Wall was standing, for a considerable distance, three and four feet high' (Bruce 1851, 117).

John Horsley described the Beehouses and stated that there was a *castellum*, that is, a milecastle, a little to the west (Horsley 1732, 136). This is now lost under the houses and other developments which have obliterated most visible traces of the Wall between Wallsend and Heddon-on-the-Wall, though excavations have demonstrated that archaeological remains often survive surprisingly well below ground, including pits on the berm – the space between the wall and the ditch – first discovered in urban Tyneside.

Reference: *Drawings* No. 2.
Laing G3851.

PLATE 3

'Pons-Aelii, Restored'

George Bouchier Richardson

This is a wonderful depiction of Roman Newcastle, a physical manifestation of George Bouchier Richardson's research into the Roman remains of the city. Looking north from Gateshead over the river, it shows the Wall coming down the hill (now Westgate Road) to meet the north-west corner of the fort, with it continuing eastwards and protecting a civil community living in its lea. The bridge, Pons Aelius, was named after Hadrian, whose family name was Aelius. The drawing captures well the problem for the Roman engineers of negotiating the many streams flowing across its line into the Tyne down river from the fort. Modern excavations have demonstrated that the fort was much smaller than the one shown here (Snape and Bidwell 2002); some remains are visible beside the Keep (the 'new castle').

References: Bruce 1851, frontispiece;
Bruce 1853, frontispiece; *Views.*

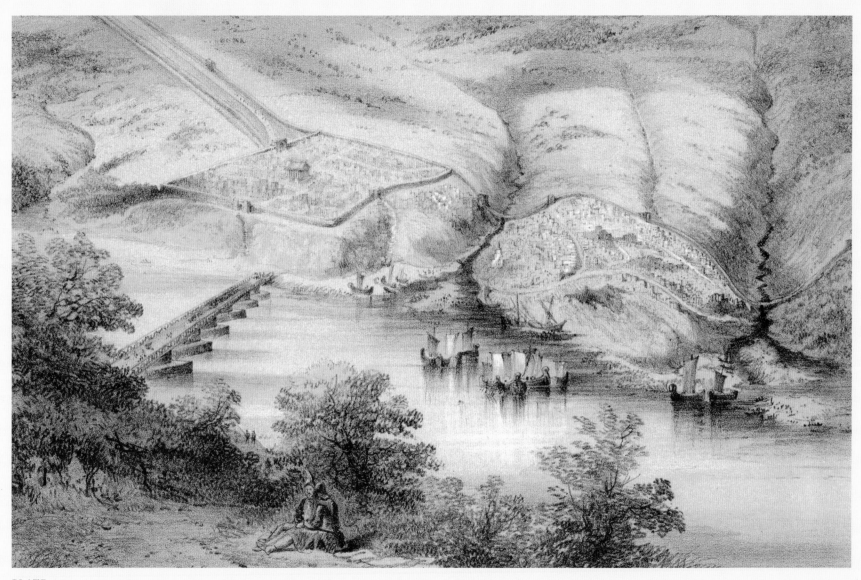

PLATE 4

Westgate Road, Newcastle

Henry Burdon Richardson

'One of the aggers [mounds] of the Vallum, at the top of Westgate Road, Newcastle, as it appears in 1848; it has since been removed.'

The view is along the north mound of the Vallum looking west, with the trees to the left marking the line of the Vallum ditch. Elswick Windmill, on the skyline, was recorded on Horsley's map of the area (Horsley 1732, 158, no. 2). It stood a little west of Quarry Hill, later the site of the Westgate Hill Cemetery at the junction of Westgate Road and Elswick Road, and where Horsley thought there was a milecastle. This is probably the most easterly depiction of the Vallum. Bruce recorded the impending destruction of the Vallum hereabouts through quarrying, and a quarry is shown on the right of the painting (Bruce 1851, 136–7; 1853, 107). In 1867, however, he could still write that 'The Vallum is seen as soon as the last row of houses in the town – Gloucester Road – is passed. It runs at the back of the windmill on the top of the hill, and behind the row of houses called Graingerville. It is seen on the left hand of the road nearly all the way to CONDERCUM [Benwell]' (Bruce 1867, 106).

Reference: *Drawings* No. 3.
Laing G3380.

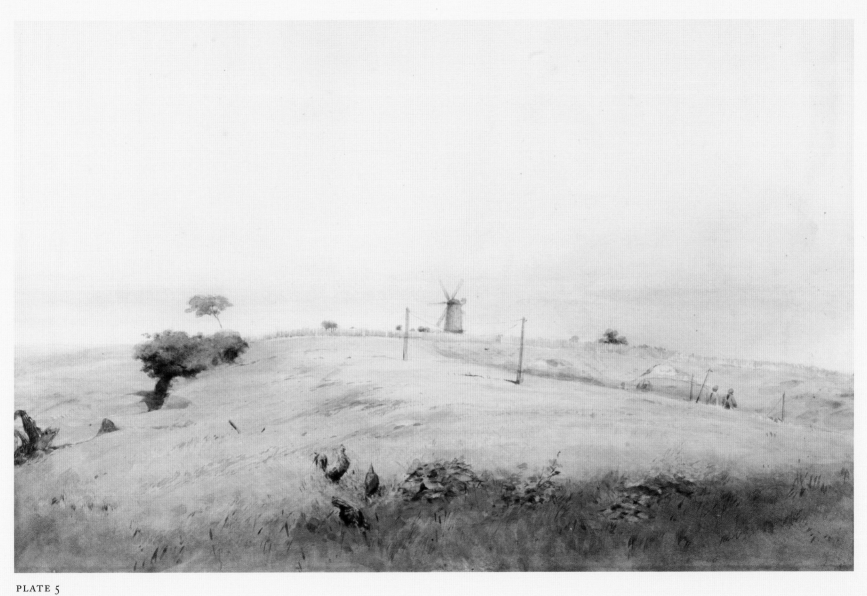

PLATE 5

Benwell hill top

Henry Burdon Richardson

———

*'The mound shown here formed the north section of
the station of* CONDERCUM*. The site now forms one of the
reservoirs of the Newcastle Water Company.'*

In commenting on the fort at Benwell in 1851 Bruce stated that 'so feeble
. . . are the traces of it which remain, that the wayfarer who does not scru-
tinize the spot very narrowly, will pass on his journey without knowing
that he is treading ground once jealously guarded by imperial power'
(Bruce 1851, 137; 1853, 107). In 1867 he recorded that the reservoir had
recently been created. In the course of the work, 'some remains of Roman
houses were met with, and the piers of the north gate were disclosed'
(Bruce 1867, 108). When the lower reservoir of the Newcastle Water
Company was formed at South Benwell in 1858, some ancient coal
workings were exposed. The southern part of the fort was developed for
housing between the First and Second World Wars following excavation.
Visible today are the Vallum crossing south of the fort and the temple to
the god Antenociticus.

———

Reference: *Drawings* No. 4.
Laing G3381.

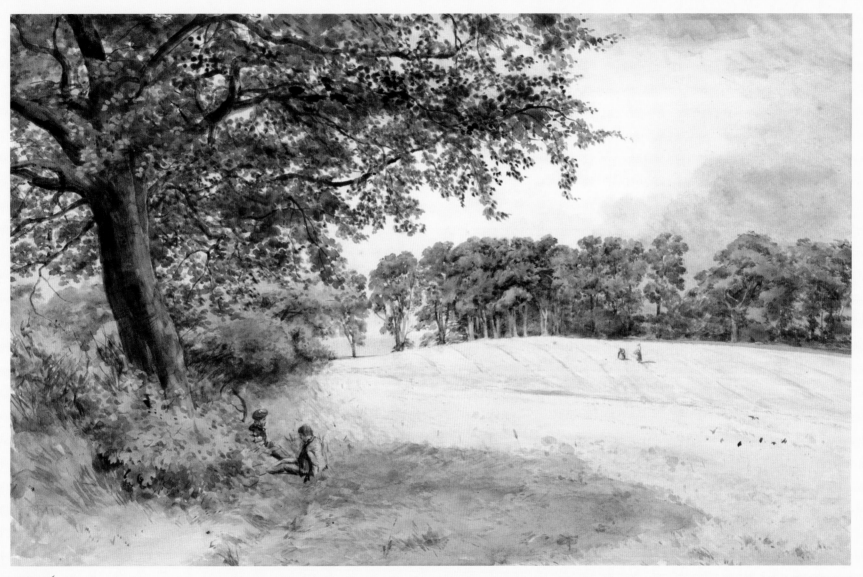

PLATE 6

East Denton

Henry Burdon Richardson

*'A fragment of the Wall near East Denton; an apple
tree once grew upon it, which no longer exists.'*

The Wall at East Denton by Thomas
Miles Richardson senior, 1823

'Here we meet for the first time with a fragment of the Wall' (Bruce 1851, 145–6). These remains are still visible. It has been the subject of several drawings, including those by William Hutton in 1802 – the earliest known – and Thomas Miles Richardson senior in 1823. This section of the Wall was purchased by the corporation of Newcastle upon Tyne in 1924.

In 1789 the Wall stood five courses high; Hutton in 1802 recorded three courses on one side and four on the other; now, no more than two survive. The stump of the apple tree disappeared in the winter of 1861. The wall is just over 9 Roman feet (2.743 m) wide, and was erected on a layer of flags bedded in clay.

References: Bruce 1851, 145; Bruce 1853, 114; Bruce 1863, 54; Bruce 1867, 119;
Bruce 1884, 48; Bruce 1885, 50 (all woodcuts); *Drawings* No. 5;
a drawing appears in Hutton 1802, opposite p. 184.
Laing G3382.

46

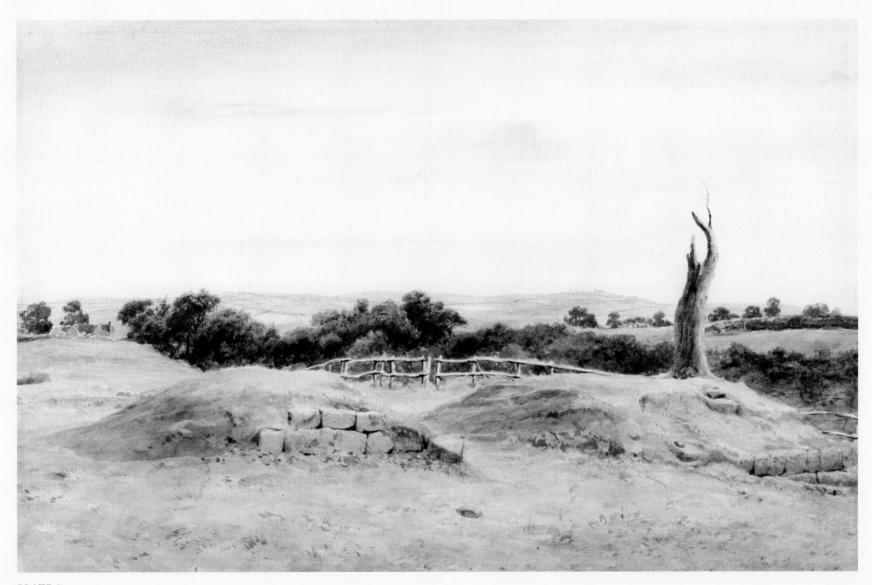

PLATE 7

Denton Hall

Henry Burdon Richardson

*'In the foreground are the works of the Vallum; further off
are the remains of the Wall in the vicinity of Denton Hall.'*

The painter is sitting on the south mound of the Vallum with the ditch in
the foreground and the north mound beyond; Denton Hall lies in the
trees. Bruce noted that 'very nearly opposite the hall, a larger mass of ruin
than usual betokens the site of a mile-castle' (Bruce 1851, 147). This mass
is the small mound in the centre of the painting. Excavation by Eric Birley
in 1930, however, demonstrated that it was not a milecastle but a turret,
T 7b (Denton); this is on public display. The turret is the only such
structure to be visible along the Wall with the originally planned Broad
Wall to each side. It retains interesting features such as the base for a stair
or ladder to an upper floor, evidence of a socket to one side of the door
probably for a bar, and the base of a small tank.

Reference: *Drawings* No. 6.
Laing G3383.

PLATE 8

Heddon-on-the-Wall
Henry Burdon Richardson

*'The south face of the Wall at Heddon-on-the-Wall. In the
back ground are seen the fosse [ditch] of both Wall and Vallum.'*

Bruce recorded that the ditch 'is deeper and bolder than it has hitherto
appeared; it must be nearly in its original perfection. The works of the
Vallum about fifty yards to the south are also finely developed. The ditch,
in both cases, is cut through the free-stone rock.' In describing the wall,
he stated that, 'its north face is destroyed but about five courses of the
southern face are perfect' (Bruce 1851, 149).

The wall here is almost 10 Roman feet (2.92 m) wide and is the longest
visible section built to the original thickness. The Wall ditch is visible
between the trees, but is now built over. The Vallum to the right was cut
through solid rock.

The engraving used in Bruce's publications, including *Views*, was by
Storey and based on a painting by Charles Richardson and not that by his
brother Henry reproduced here.

References: Bruce 1851, facing p. 149; Bruce 1853, facing p. 117;
Bruce 1867, facing p. 124; *Views*; *Drawings* No. 7.
Laing G3384.

PLATE 9

Harlow Hill

Henry Burdon Richardson

*'The road which is here making straight for Harlow-Hill
occupies the site of the Wall; the groove on the right of the road
is the fosse which accompanied the Wall on the north side.'*

The poor roads of the area prevented the Hanoverian army stationed at Newcastle from intercepting Bonnie Prince Charlie in 1745 on his march south through Carlisle. As a result, an Act of Parliament was passed in 1751 approving the construction of a road, known today as the Military Road, between Newcastle and Carlisle; work started in July of that year. For 48 km westwards from Newcastle the road was laid on top of Hadrian's Wall, and it is still there. Hence the modern B6318, the Military Road, runs in straight lines, changing direction on the top of each hill. However, the hills are not triangular in shape, but rather are whale-backs. The change of direction therefore occurs at the far side of the hill from the surveyors' start point. In this way, it can be determined which way Hadrian's Wall was surveyed (Poulter 2010).

Reference: *Drawings* No. 8.
Laing G3385.

PLATE 10

Down Hill

Henry Burdon Richardson

'The Vallum at Down-Hill, about fifteen miles from Newcastle.
The works bend at an angle to avoid the hill. The turnpike road represents
the Wall; the north fosse [ditch] is seen to the left of it.'

The Wall, to the left in this view looking eastwards, goes over the top of the hill; the modern road swings round it to the north, while the Vallum takes a southerly turn. Here, the Vallum is also well preserved and its essential features are well depicted: the central ditch with a mound set back on each side. A sheep stands on one of the later crossings over the ditch.

In 1851 Bruce was still arguing the case in favour of the Wall having been constructed by Hadrian and that the Wall and the Vallum were contemporary – 'all the lines of the Barrier are but parts of one great engineering scheme' (Bruce 1851, 156–7).

Charles Richardson produced 'a sepia drawing of the aggers of the Vallum near Down Hill'.

References: Bruce 1851, facing p. 156; Bruce 1853, facing p. 124;
Bruce 1867, facing p. 132; *Views; Drawings* No. 9.
Laing G3386.

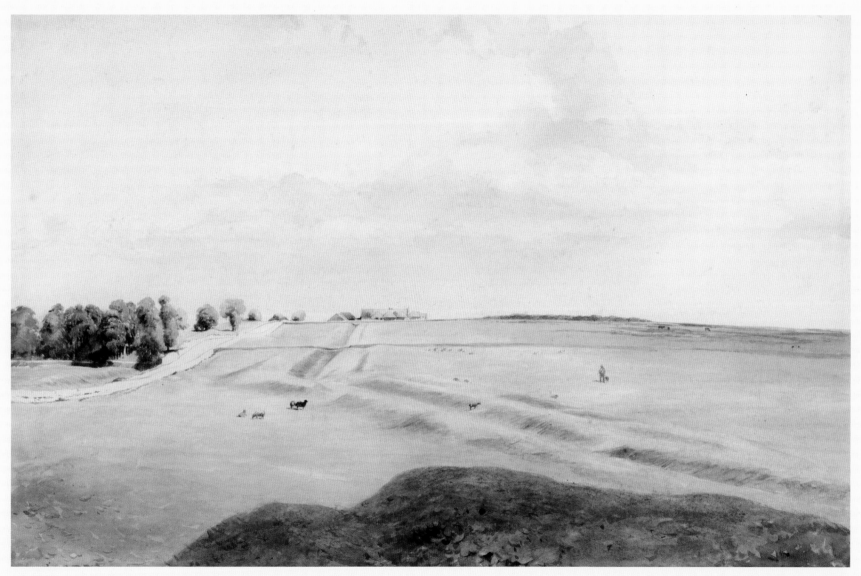

PLATE II

Brunton Bank

Henry Burdon Richardson

'In the foreground is the core of the Wall as it appears on Brunton Bank. Carrying the eye forward the Wall is seen, after having crossed the North Tyne, passing Chesters and running up the hill to Walwick.'

The painter is sitting a little to the west of Planetrees looking across the valley of the North Tyne. This lovely depiction of the Wall in its landscape was not used in any publication. The valley of the North Tyne is one of the most picturesque parts of the Wall. However, in Roman times it appears to have been perceived as a weak point as the structures blocking north–south movement seem to have been prioritised in the building programme (Graafstal 2012).

Reference: *Drawings* No. 10.
Laing G3391.

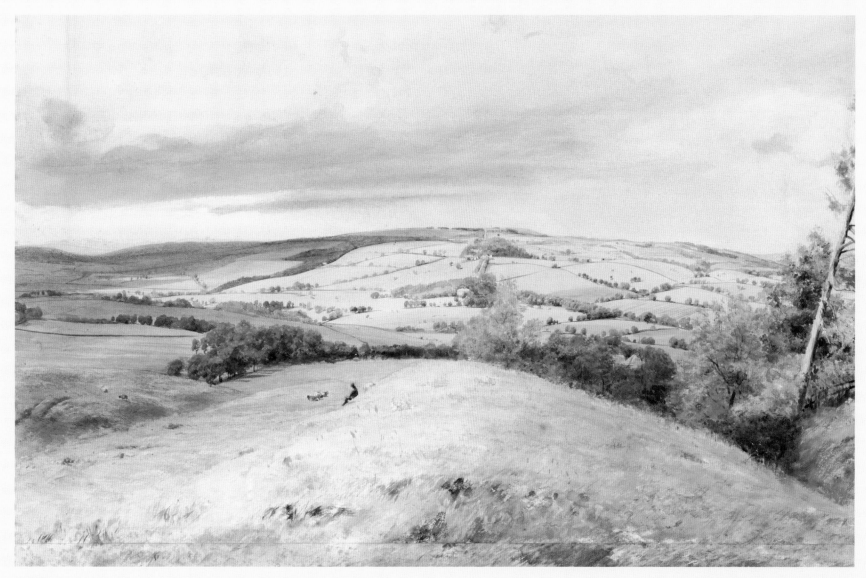

PLATE 12

Brunton

Henry Burdon Richardson

*'The north face of the Wall within the grounds of East Brunton, North Tyne.
An uninscribed altar and some other stones are placed against the Wall.'*

When Bruce visited, this section was 'seven feet high, and presents nine courses of facing-stones entire. The mortar of the five lower courses is good; the face of the south side is gone. The ditch also is here well developed. . . . The altar which, at present, stands as it is placed in the drawing, formerly discharged the office of gate-post at the entry of the yard of St Oswald's chapel' (Bruce 1851, 169–70). In 1867 the altar was still in place and Bruce adds that, 'it is uninscribed, but is carved on both sides' (Bruce 1867, 143).

This remains a well-preserved stretch of wall beside T 26b (Brunton), itself of special interest in view of the way the Narrow Wall rides up over the eastern wing-wall while the western wing-wall was subsumed into the Broad Wall. The berm – the space between the wall and the ditch – here narrows as it does in some other locations along the Wall (Bidwell 2005).

References: Bruce 1851, facing p. 169; Bruce 1853, facing p. 140;
Bruce 1867, facing p. 143; *Views*; *Drawings* No. 11.
Laing G3387.

58

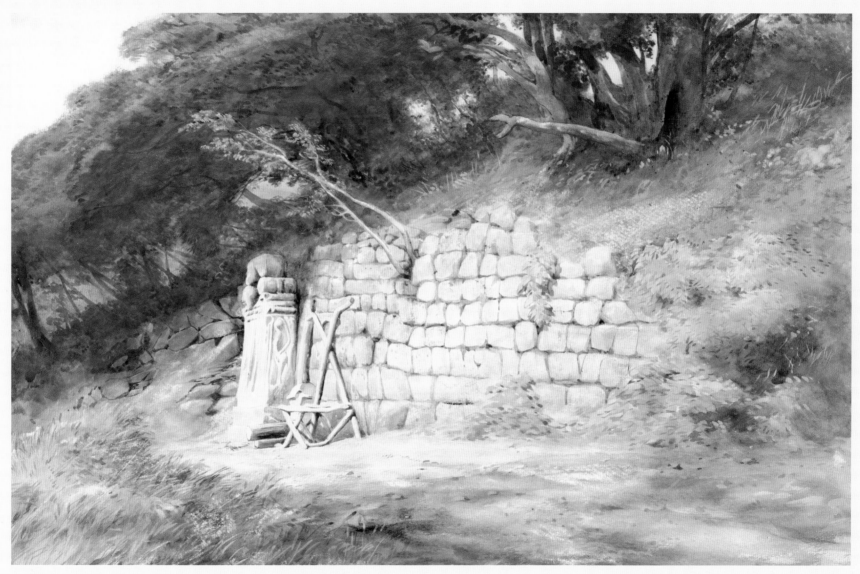

PLATE 13

Chesters bridge abutment

Henry Burdon Richardson

'The land abutment at the east end of the bridge which crossed the North Tyne at CILURNUM. *The Wall, coming from the east, is seen to terminate in a square tower, which is embraced by the works of the abutment.'*

The bridge abutment was uncovered by John Clayton in 1860, work continuing until 1863.

It was re-examined in 1982–3 (Bidwell and Holbrook 1989, 1–49). In the painting on the left, the figure in the centre is standing on the first pier of the earlier bridge; this was on the line of the Wall and appears to have been designed for foot traffic only. It was subsumed within the abutment of a bridge probably erected in the later second century. This bridge carried a road over the river. A water channel passed through the tower and may have led to a mill downstream.

References: The painting on this page is reproduced in Bruce 1867, facing p. 144 (unacknowledged); *Drawings* Nos. 12, 12a, 12b and 12c. Laing G3388; other views are G3390, G3392, G10340.

(All four watercolours, together with a further four by David Mossman, are reproduced in Bidwell and Holbrook 1989.)

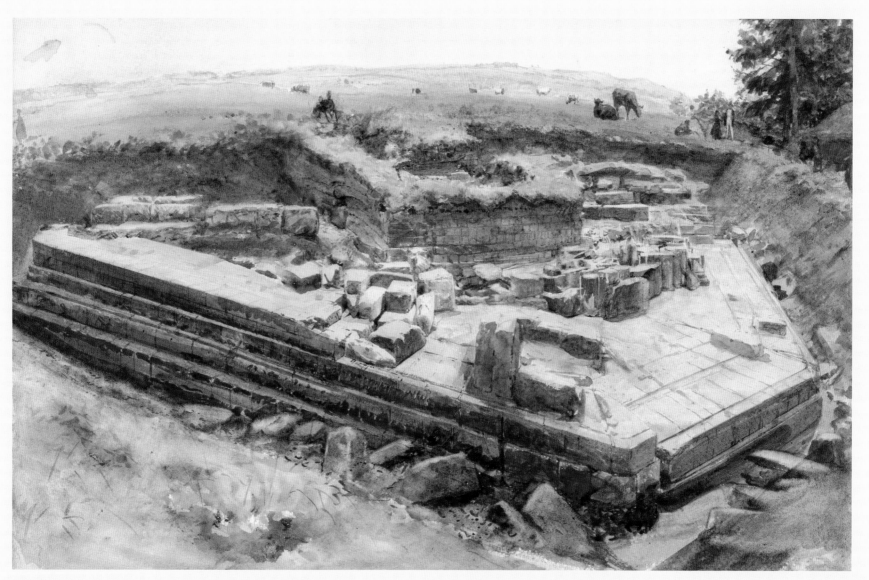

PLATE 14

Chesters fort, the east gate

Henry Burdon Richardson

'The northern gateway in the east rampart of CILURNUM, *showing the two portals and guard-chambers. The Wall is seen coming up to the southern jamb of the gateway. The spectator is looking southwards along the rampart.'*

This gate was examined in 1867 and, as the edges of the excavated area are still sharp, the painting would appear to show it soon after this work. The artist is looking south with the two portals of the gate in the foreground and the Wall at the far end of the trench running east–west to join the fort at the south tower of the gate; John Clayton recorded that 'the two structures are obviously distinct and separate works', though the two now appear to be bonded following consolidation of the remains (Clayton 1876a, 172). The two portals of the gate both lie north of the Wall. The rear arch of the south portal (back right) is one of the highest standing elements of the Wall.

References: Budge 1907, 101; *Drawings* No. 13.
Laing G3872.

62

PLATE 15

Chesters fort,
commanding officer's house
Henry Burdon Richardson

John Storey's engraving of the bath-house.
This depiction of the bath-house became
one of the iconic views of Chesters.

'The hypocaust of one of the excavated chambers at Chesters, on the North Tyne. The pilae *consist partly of stone columns taken from disused buildings and partly of pillars formed of tiles.'*

Nathaniel Clayton purchased the Chesters estate in 1796 but he does not appear to have been interested in the Roman ruins that lay in front of his house and undertook some landscaping to level the ground. His son John spent decades unearthing the Roman buildings. He started in 1843 when he uncovered part of what was later identified as the house of the commanding officer, though it has subsequently been suggested that this bath-house was built in the fourth century for the use of all the soldiers based at the fort; the use of columns from elsewhere to construct the hypocaust indicates that it is not original. The furnace of the bath-house is to the right. The hot air flowed under the raised floor and heated the stones which would have been covered with plaster; the bather would have worn sandals to protect his feet.

References: Bruce 1851, facing p. 178; Bruce 1853, facing p. 147;
Bruce 1867, facing p. 150; *Views, Drawings* No. 14.
Laing G3871.

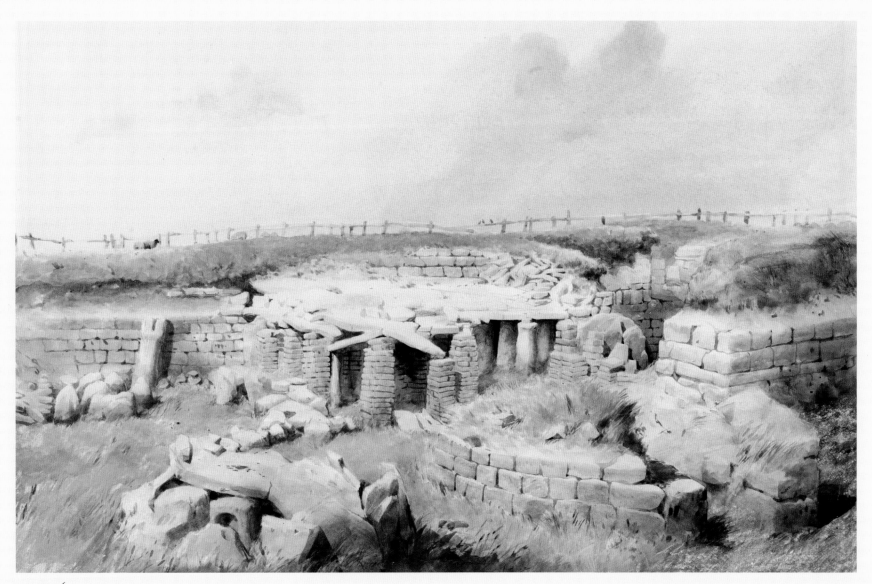

PLATE 16

The commanding officer's house at Chesters

Charles Richardson

This is the same view that was painted by his brother. By the time that this and the other two paintings of the commanding officer's house had been created by Charles Richardson, Bruce recorded that 'eight apartments [that is, rooms] have already been exposed' (Bruce 1851, 174–7). At that date, red plaster still survived on the walls of the hot room by the furnace. Bruce recorded the arrangements by which hot air moved round the building under the floors and through the walls via flues. Excavation of the house continued into the 1880s and 1890s, with the clearing of the rooms recorded in the plans published in Bruce's books (Bruce 1851, opposite p. 174; 1884, plan between pp. 82 and 83; Blair 1895, plan between pp. 88 and 89).

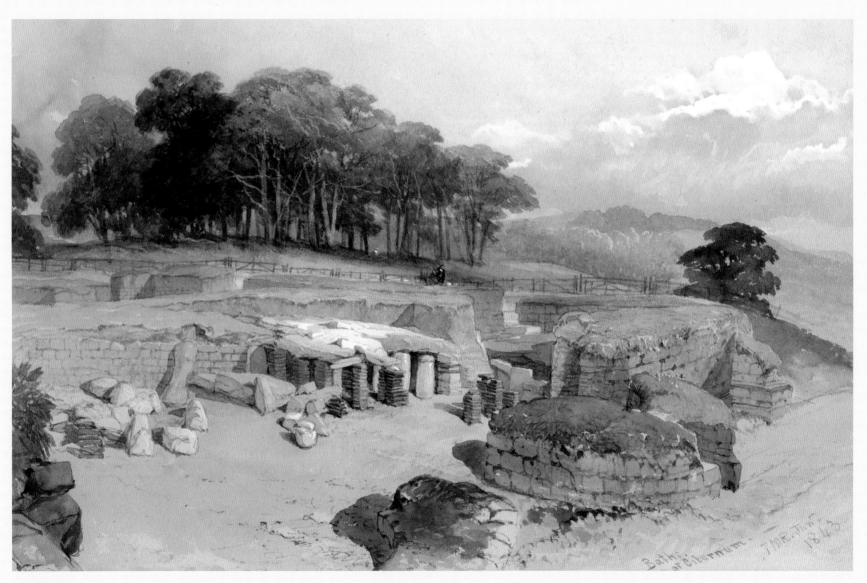

Bath, or Cilurnum. J.M.R. June 1843

PLATE 17

The commanding officer's house at Chesters

Charles Richardson

In this view Charles Richardson has located himself so that he can look eastwards down into the valley of the North Tyne and the bridge over the river at Chollerford. The two rooms with raised floors formed part of the commanding officer's bath-house being located to the west of the apsidal furnace, but apparently separated from the hottest rooms by a corridor. They were opened up by Clayton shortly before 1851 (Bruce 1851, 175).

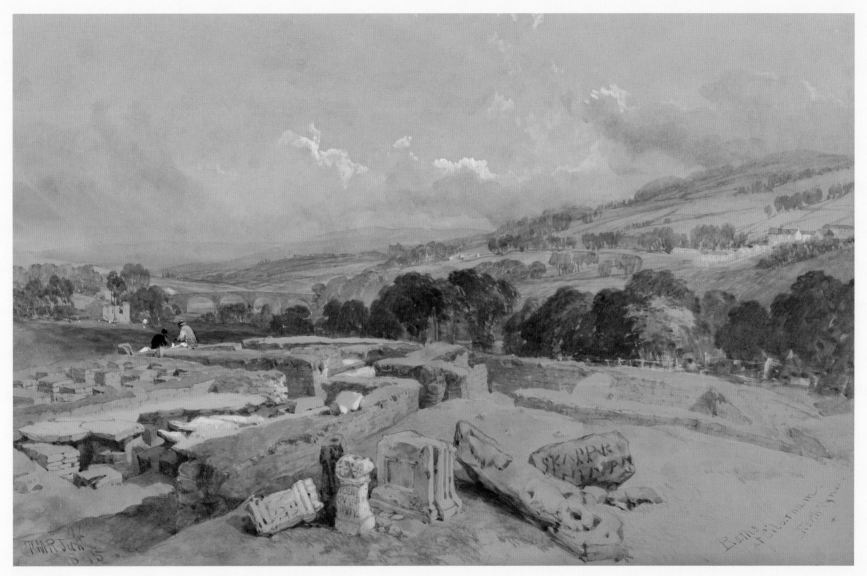

PLATE 18

The commanding
officer's house at Chesters

Charles Richardson

In his third painting, Charles Richardson offers a view along the north wall of the house with the hot room of the bath-house (the *caldarium*) with its apsidal furnace to the left (Bruce 1851, 175). In the second gap in the wall to the right a statue of a river-god was found which Charles recorded (Clayton 1844, 143–4; Budge 1903, 103).

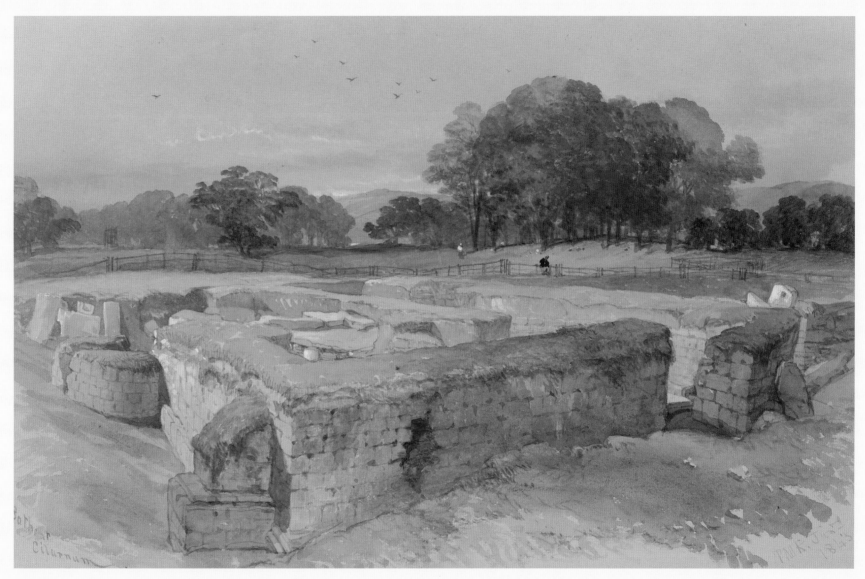

PLATE 19

The bath-house at Chesters

Charles Richardson

'Coloured drawing of the new excavations
near the river at Cilurnum; looking south'

The second painting by Charles Richardson
of the bath-house looking south.

This building was found in 1885 while digging drains and subsequently completely excavated. Charles Richardson painted the bath-house twice from three different angles. In this, he is looking along the length of the building, with the hot dry room, with its own furnace, to the right, the changing room to the left and the ranges of hot rooms beyond. The treatment in the hot dry room was similar to that in a modern sauna while the hot rooms were the equivalent of a Turkish bath (this form of bathing acquired its name when the Turks captured the Eastern Roman Empire and took over the Roman bathing style). A barrel-vaulted roof ran along the length of the bath-house; several of the voussoirs from the roof remain on the site.

Laing G3854/H12843.

72

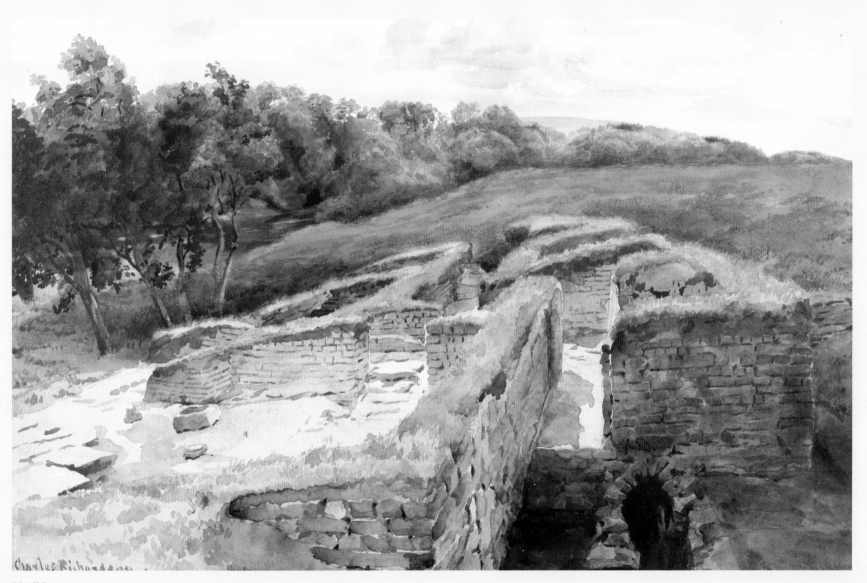

Charles Richardson

PLATE 20

The bath-house at Chesters

Charles Richardson

'Coloured drawing of the new excavations
at Cilurnum; looking eastwards.'

The second painting by Charles Richardson
of the bath-house looking east.

Charles Richardson has taken a position which shows the height of the
bath-house to good effect, for this is one of the highest standing buildings
surviving from Roman times in Britain. We see the hot dry room to the
left, the hot bath, with a window, in the centre, and the furnace to the
right. This is one of several bath-houses built along the line of Hadrian's
Wall to the same plan, and reflects a strong measure of standardisation in
the building programme for the Wall. The detail extended to the use of
multiples of 10 Roman feet in the construction of this bath-house.

Laing G10349/H12845.

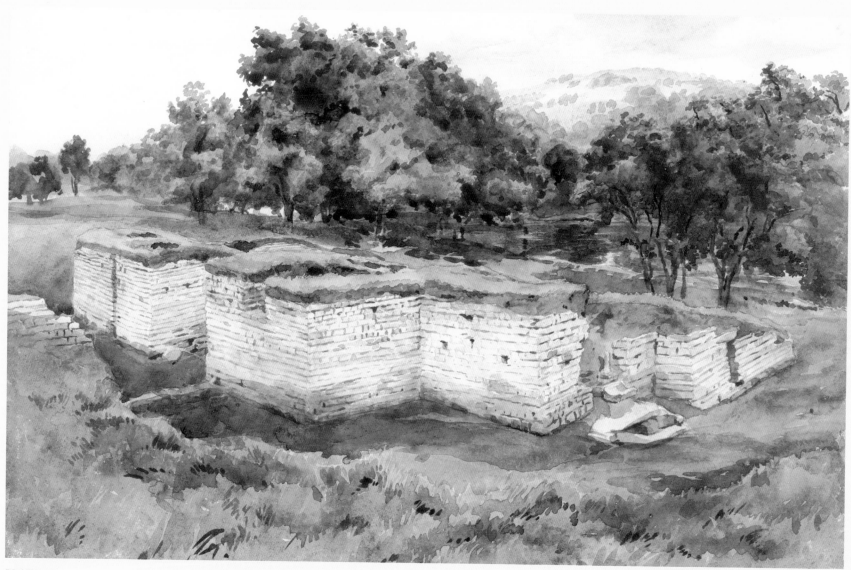

PLATE 21

The bath-house at Chesters

Charles Richardson

———————

*'Coloured drawing of the new excavations
at Cilurnum; looking westwards.'*

The second painting by Charles Richardson
of the bath-house looking west.

Charles Richardson has chosen another spectacular viewpoint, looking across the ruins from a spot above the river bank. The row of seven arches – receptacles for clothes or niches for sculptures of deities? – form part of the south wall of the changing room, with the rooms of the hot range to the left. In the foreground is the latrine. This was flushed by the water running downhill from within the bath-house. The sewage appears to have debouched down the hillside towards the river. The floor of the changing room was raised at least once during its life. The visible floor has suffered over the years: on excavation, it was nearly complete. The arches are re-used window heads.

———————

Reference: Budge 1907, 109.
Laing G3855/H12844.

76

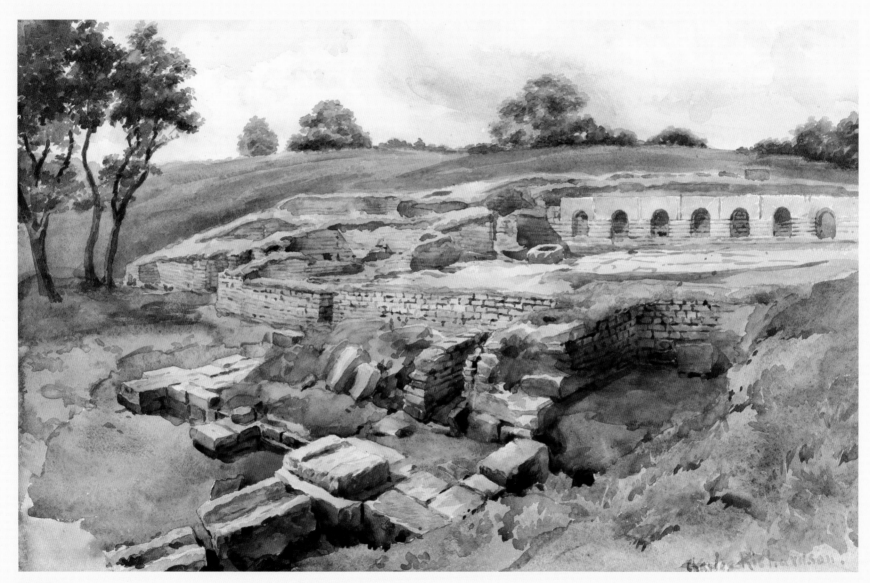

PLATE 22

The hot bath in the
bath-house at Chesters

Charles Richardson

The final painting by Charles Richardson is a detail. This is the apsidal hot bath. This once had a raised floor under which circulated the air heated in the adjacent furnace. Over the furnace sat a boiler from which very hot water would circulate into the bath. The pink tinge on the walls represents the plaster which once completely covered the walls. Resting on the low wall to the right is one of the voussoirs from the roof. We can only presume that the window would once have had glass.

Laing H12847.

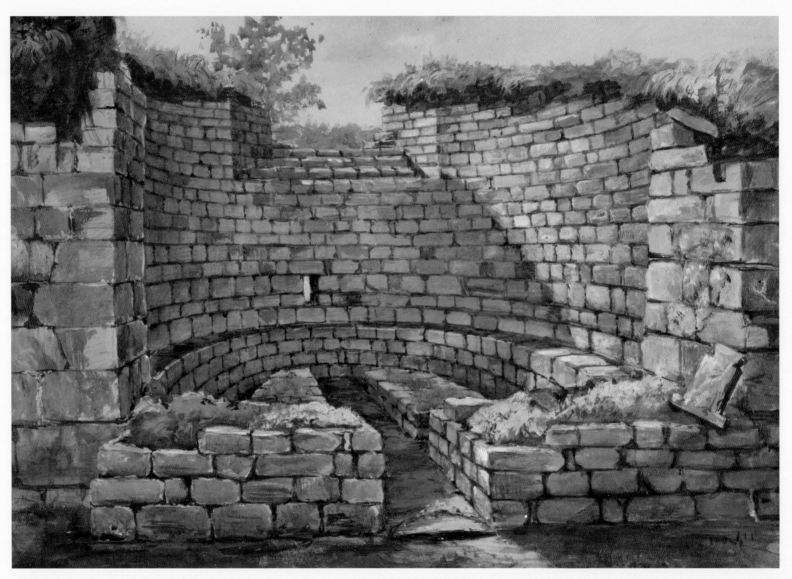

PLATE 23

The cemetery at Chesters
Thomas Miles Richardson junior

'View from the Roman burial ground, Cilurnum'

The Roman cemetery at Chesters lay to the south-east of the fort towards the river. It has not been excavated but some tombstones have been found there. In this engraving Richardson has placed two tombstones which it is recorded were discovered here but had been removed to the collection of the Duke of Northumberland in Alnwick Castle by the time the illustration was created; they are now in the Great North Museum in Newcastle. Bruce was eloquent about the location of the cemetery: 'no earthly music could better soothe the chafed affections of the hopeless heathen mourner than the murmur of the stream which is ceaselessly heard in this secluded nook' (Bruce 1867, 155–6).

Reference: Bruce 1867, facing p. 155.

PLATE 24

Tower Tye

Henry Burdon Richardson

'The summit of the hill west of Tower-Taye. All the works are seen as they ascend the Limestone Bank. On the right, on Blackcarts farm, is a fine piece of Wall, which has been cleared since this sketch was made.'

Bruce helpfully informs us that the spot was named after a tower erected in about 1730 (Bruce 1867, 166). The painting was not used in any of Bruce's publications. The Vallum ditch lies immediately to the left of the modern road with the south mound to its left; the Military Road has been built on the north mound. The Wall ditch is to the right of the road. MC 29 (Tower Tye) lies behind the trees to the right; it is one of the very few milecastles known to have been surrounded by a ditch, which can still be seen, though the remains are complicated by the depressions left by the robbing of the milecastle walls. The 'fine piece of wall' leads on to T 29a (Blackcarts).

Reference: *Drawings* No. 15.
Laing G10319.

PLATE 25

Blackcarts turret

Henry Burdon Richardson

———————

'The turret on Blackcarts farm, excavated 1873.
The only existing specimen of any importance.'

This turret had to wait until 1884 to appear in one of Bruce's books. In the second edition of the *Hand-book*, he acknowledged that Mr Clayton had uncovered it in 1873, provided measurements and then went on to say 'like the turret at Brunton, it is let into the Wall; but the Wall for a short distance on each side of it is made thicker than usual. The front wall of the turret is nearly gone . . . but its back is fourteen courses high. In the south front is a doorway three feet wide' (Bruce 1884, 109). This brief description encapsulates the main features: that turrets were recessed into the Wall; to each side of the turret there was a wing-wall and a point of reduction where the Wall was narrowed from the original 10 Roman feet; and there was a doorway, the location of which became important later in seeking to determine the particular legionary builder.

———————

References: Bruce 1884, 108; Bruce 1885, 119; *Drawings* No. 59.
Laing G5685.

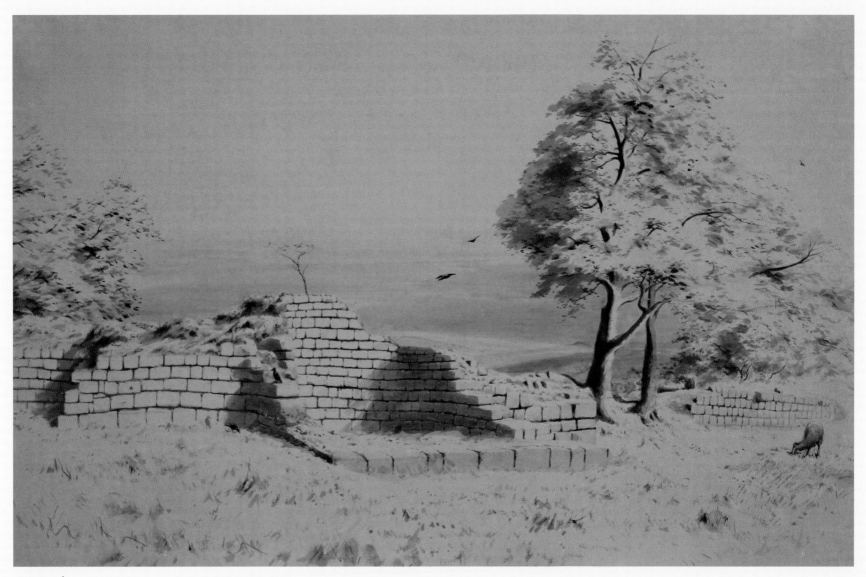

PLATE 26

The Wall ditch at Limestone Corner

Henry Burdon Richardson

*'The fosse [ditch] on the north of the Wall on the top of Limestone Bank,
showing the masses of basalt which have been taken out of the fosse.'*

As Bruce notes, the 'fosse of the Wall and the Vallum at this point deserve
attentive examination. In passing over the crown of the hill, they have been
excavated with enormous labour out of the basalt of which the summit
consists. The workmen, as if exhausted with the task of raising the splin-
tered fragments, have left them lying on the sides of the moats. A mass
on the outside of the north ditch, though now spilt by the action of the
frost into three pieces, has evidently formed one block, and cannot weigh
less than thirteen tons. It is not easy to conceive how they managed to
quarry so tough a rock without the aid of gunpowder, or contrived to lift,
with the machinery at their command, such huge blocks' (Bruce 1851, 196–
7); see also p. xiv above. In fact, the Romans had a variety of cranes available
for such tasks (Hill 2006, 80–4).

Reference: *Drawings* No. 18.
Laing G10320.

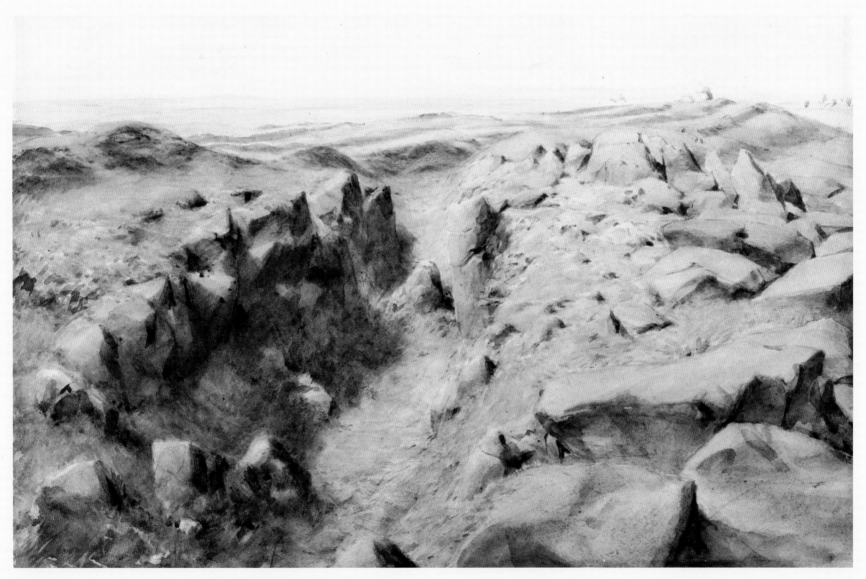

PLATE 27

The Vallum at Limestone Corner

Henry Burdon Richardson

The engraving used in *The Roman Wall* is based on this view by Henry Richardson.

'The Vallum as it is seen to the west of Limestone Bank. The fosse [ditch] of both Vallum and Murus [Wall] have been cut through a masse of basalt. Large blocks of the rock encumber the surface. In the distance are the basaltic dikes over which the Wall runs in its course westward.'

Richardson created three different images of this view, all looking westwards from the west end of the wood immediately south of Limestone Corner towards Carrawburgh Farm, which is visible sitting on the south mound of the Vallum. A fourth image, credited to J. S. Kell, is in the third edition *of The Roman Wall*.

In various places evidence for a track has been found on the berms of the Vallum, and its use as a communications route has therefore been suggested. The existence of the large boulders on the berm at Limestone Corner demonstrates that, here at least, this would not have been practical. Tracks along the Wall have been recorded elsewhere.

References: Bruce 1851, facing p. 197; Bruce 1853, facing p. 164; *Views*, *Drawings* No. 16 (17 and 17a are similar); for the version by Kell see Bruce 1867, facing p. 168. Laing G10321, G3873, G3393.

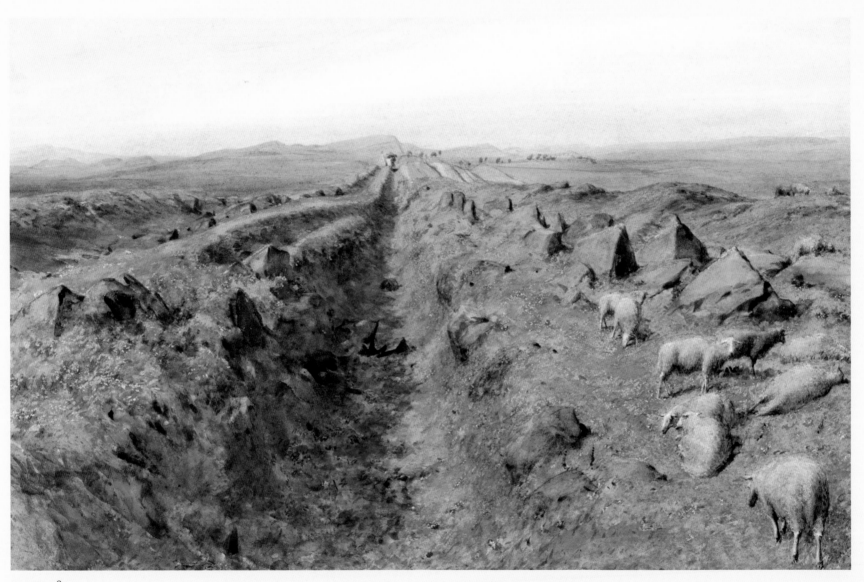

PLATE 28

The approach to Sewingshields

Henry Burdon Richardson

'A view showing the roots [sic] *of the Wall and the north fosse [ditch] as they climb the hill on which Sewingshields farm-house stands. The Vallum keeps to the low ground on the left.'*

'The farm-house [is] perched on the summit of the hill in the centre of this view. The Vallum takes the "tail" of the hill' (*Views*). At this point, Hutton in 1802 observed that he 'quit the beautiful scenes of cultivation, and enter[ed] upon the rude of nature, and the wreck of antiquity' (Hutton 1802). Bruce, in simpler language, explained that the 'north fosse [Wall ditch], which we have had in view from the very commencement of our journey, accompanies the Wall for a short distance up the hill, as is seen in the lithograph, but when the ground becomes precipitous, it forsakes it until high grounds are passed, only to appear when the Wall sinks into a gap or chasm between the crags' (Bruce 1851, 201).

References: Bruce 1851, facing p. 200; Bruce 1853, facing p. 168; Bruce 1867, facing p. 173; *Views*; *Drawings* No. 19. Laing G3396.

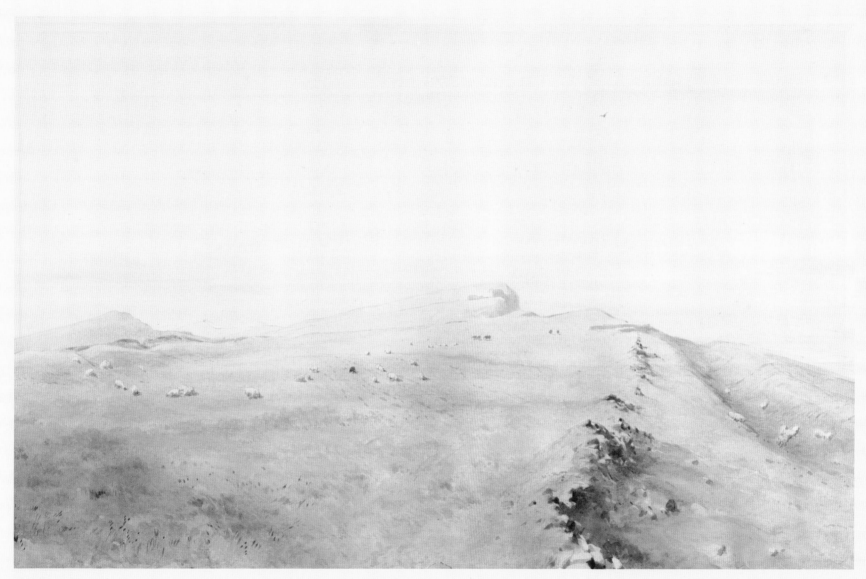

PLATE 29

Housesteads platform

Henry Burdon Richardson

'The platform of the station of BORCOVICUS. *The Wall is seen to approach it from the east, and, after leaving the western rampart, to pursue its course onwards to Peel Crag and Winshields'*

Bruce uses this view to aid his description of the site of the fort at Housesteads. 'The site of the station is skilfully chosen. It consists of a platform somewhat elevated above the contiguous ground, but much less exposed to the blasts which sweep the mural chain than the cliffs to the east or the west of it' (Bruce 1867, 180). Bruce's description could hardly be bettered. In the lower foreground, beside the Knag Burn, a gate was later inserted through the Wall (by the figure in the painting). Its purpose was presumably to allow travellers – perhaps herdsmen – to cross the frontier without passing through the fort.

References: Bruce 1867, facing p. 180; *Drawings* No. 20.
Laing G10322.

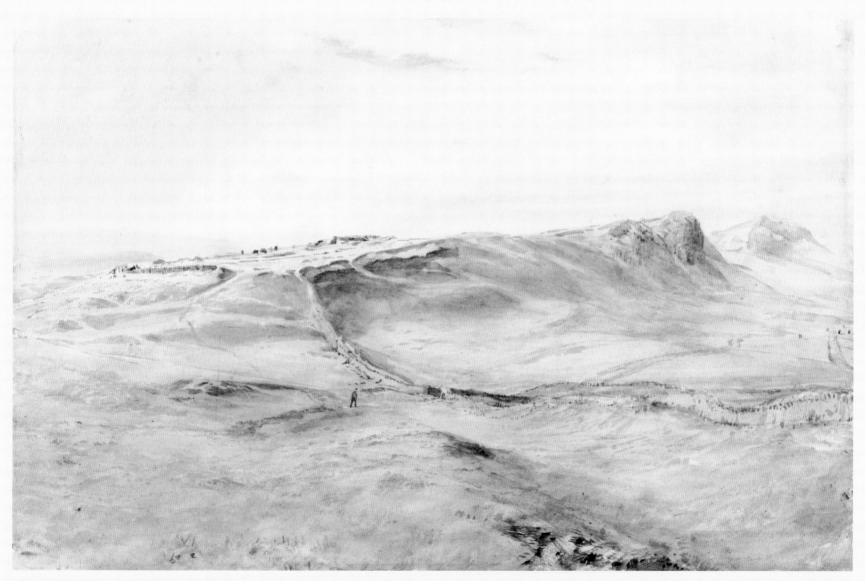

PLATE 30

Housesteads

Thomas Miles Richardson junior

This painting shows the farm below the south rampart of the fort at House-steads in about 1850; it is also visible on Plate 32. Shortly after 1860 Clayton moved the farm to its present position, a short distance to the south of the museum (Woodside and Crow 1999, 144). The circular wall protecting the well is all that remains to mark the position of the earlier farm steading. Clayton's action was part of his campaign to free the archaeological remains from later intrusions.

References: Bruce 1853, 181; Bruce 1863, 126; Bruce 1867, 180; Bruce 1884, 137; Bruce 1885, 149.

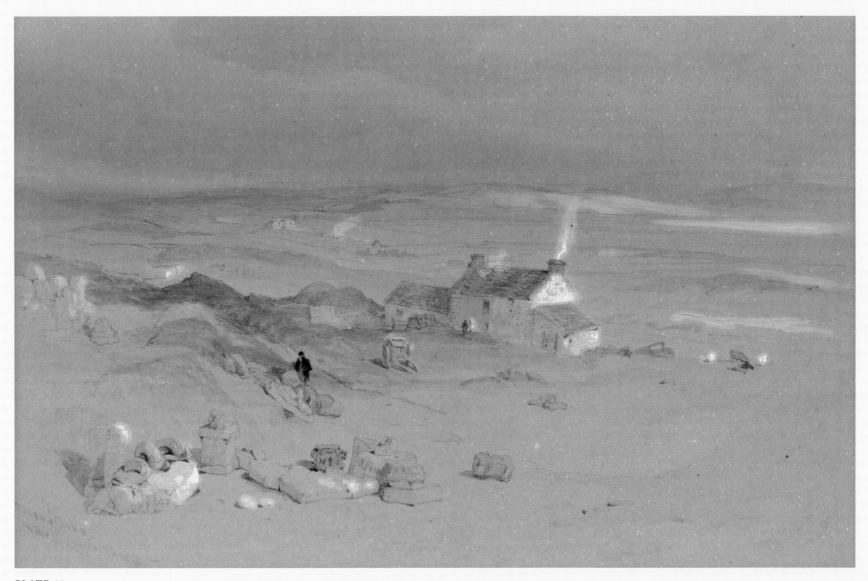

PLATE 31

The east gate at Housesteads
Henry Burdon Richardson

'The east gate of Housesteads, as it appeared in 1848;
shewing [showing] the ruts of the chariot wheels.'

Housesteads east gate by John Storey

Bruce commented on this view that it 'gives a general idea of the scene of desolation which it presents. The only habitation near is a shepherd's cottage to the south of the station' (Bruce 1851, 220; see page 95). He continued, 'a peculiarity in the upper [that is, right] division of the eastern gateway requires attention; the lower division . . . has been walled up at an early period. A rut, nearly nine inches deep, appears in the threshold, on each side of the central stone against which the gates closed.' Tradition has it that George Stephenson took the gauge of the railway from the width of the ruts at this gate, but, alas, the truth is more prosaic: he measured 100 cart widths and took the average, and in any case the ruts at Housesteads were discovered after the gauge had been set. The engraving by Storey is from a slightly different angle.

Henry Richardson also produced 'a large sepia drawing of the East Gate of Borcovicus as it was in 1848' (*Drawings* 70).

References: Bruce 1851, facing p. 220; *Views*; *Drawings* No. 22.
Laing G3395.

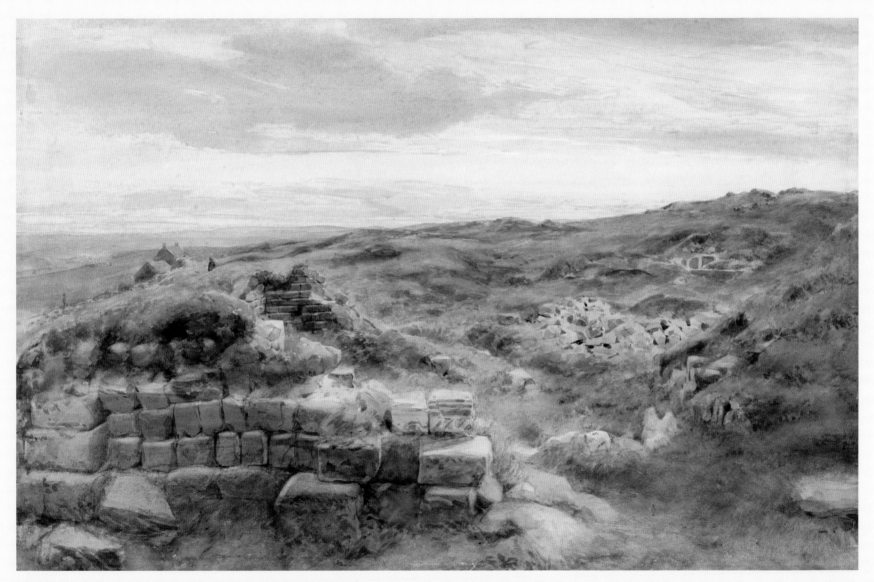

PLATE 32

The north gate at Housesteads

Henry Burdon Richardson

'The north gateway of Housesteads. The mass of rubbish on the right, which the honest Walter Rutherford (now no more) is removing, shows the extent to which the whole of this piece of masonry was covered up.'

This gate 'has but just been disclosed to the eye of the antiquary', it was reported in 1853, and 'is perhaps the finest and most colossal piece of work on the Roman Wall' (Bruce 1853, 186–7); this was stated before Chesters bridge abutment was unearthed. The discovery of the gate was unexpected and important: Bruce recorded that 'we must abandon, therefore, the idea that the Wall was meant to be the *Ultima Thule* of Roman Britain, or that it was intended simply to dam back the tide of Caledonian aggression. It was probably regarded by the Romans as a line of military operation, – a work, under cover of which they could conveniently marshal the forces for aggressive warfare, or recover their order in case of temporary surprise' (Bruce 1853, 187).

This painting, and that of the west gate, in their detail are very different from those undertaken in 1848, indicating that Richardson had greater time at his disposal to create the image.

References: Bruce 1853, facing p. 187; *Drawings* No. 21.
Laing G10342.

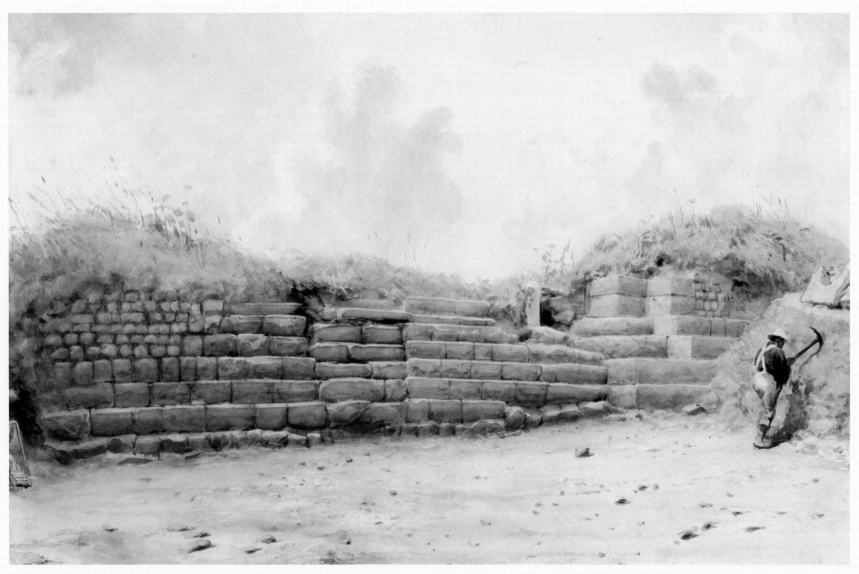

PLATE 33

The west gate at Housesteads
Henry Burdon Richardson

'The west gate of Housesteads.'

This gate had been disinterred by John Hodgson in the early 1830s, and a creditable plan was published showing the late Roman blocking of two of the portals (Bruce 1851, 216–17). Clayton set his men to complete the work in 1851. The chambers 'were found to be filled with rubbish so highly charged with animal matter as painfully to affect the susceptibilities of the labourers' (Bruce 1851, 219). The result of their labours is not only one of the best surviving gates on Hadrian's Wall, but also an instructive lesson in its own right. Several of the large blocks at the bottom of the gate bear marking-out lines for positioning the upper courses, while the rougher finishing of the top courses demonstrates the deterioration of craftsmanship in the later stages of building the Wall.

The south gate only appears in the third edition of *The Roman Wall* (Bruce 1867, facing 185) in an engraving by Storey. Bruce noted that the 'rubbish' filling the gate was partly removed in 1830, with the task completed in 1852 (Bruce 1853, 185).

References: Bruce 1867, frontispiece (unacknowledged); *Drawings* No. 23.
Laing G3394.

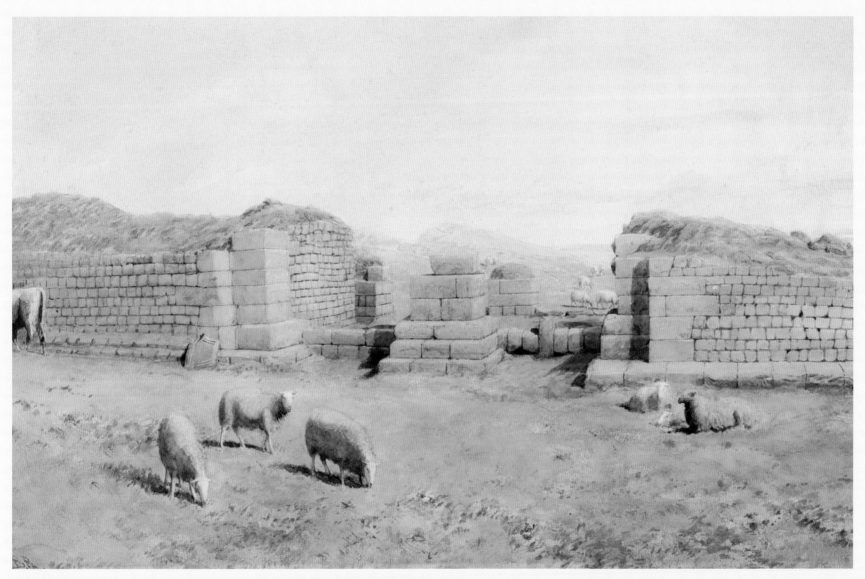

PLATE 34

Cuddy's Crag milecastle

Henry Burdon Richardson

*'The interior of the mile-castle at Cuddy's Crag
(west of Housesteads); showing the levels and the doorways of the
early and late period of Roman occupation.'*

The milecastle was excavated by Clayton in 1853. Among the discoveries was an inscription recording its building under the Emperor Hadrian.

In his third edition of *The Roman Wall*, Bruce discussed the significance of the discovery of the north gates of milecastles. 'If the Wall had been intended to form the boundary of the empire, it would not have been provided with nearly a hundred gateways leading through it. The fact of such an arrangement shows that the territory north of the Wall was not given up to the enemy; and that the Wall itself was not a mere fence, but a line of military operation, intended to overawe a foe, whose assaults were chiefly to be expected from the north' (Bruce 1867, 73–4). Here, Bruce is envisaging two functions for the Wall, a barrier and a base for military operations to the north, in words similar to those used by Horsley over a hundred years earlier (Horsley 1732, 125).

References: Bruce 1867, facing p. 73 (engraved by Kell; there is a different version by Storey in Bruce 1867, facing p. 202); *Drawings* No. 25.
Laing G10341.

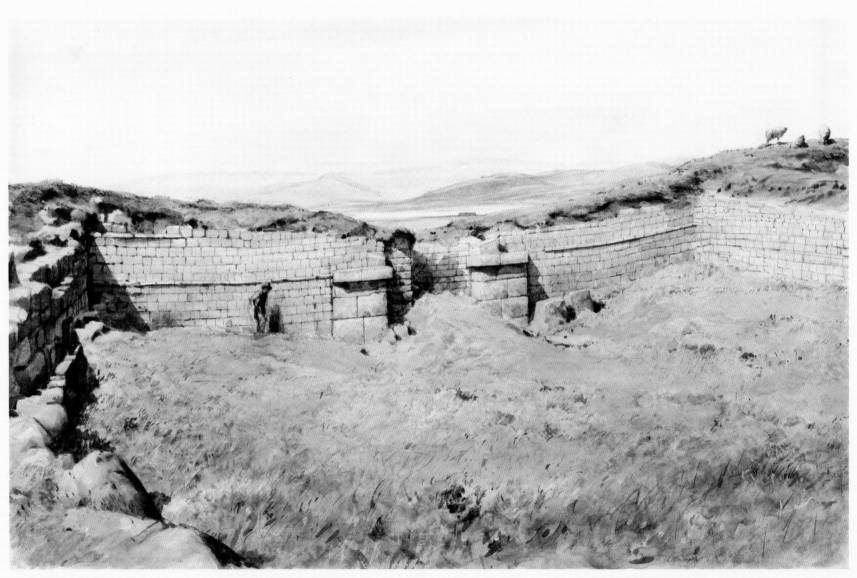

PLATE 35

Rapishaw Gap
Henry Burdon Richardson

———

*'Rapishaw Gap. The Wall on its course
eastwards, Crag-Lough to the left.'*

This is one of the many 'gaps' in the crags sector of the Wall, which runs for 19 km (12 miles) from Sewingshields to Carvoran. They vary considerably in size. Bruce noted that this was 'a more extensive pass' than usual, with a road running through it (Bruce 1851, 230). At this point, he suggested, 'the traveller may here with advantage go to the north of the Wall, in order to examine the geological character of the cliffs he has passed; they are seen "to rise in rude and pillared majesty".' He also noted that in the gap 'the ditch is resumed on the north side of the Wall' (Bruce 1853, 201).

———

References: Bruce 1863, 141; Bruce 1867, 206; Bruce 1884, 151;
Bruce 1885, 163 (all woodcuts); *Drawings* No. 27.
Laing G10326.

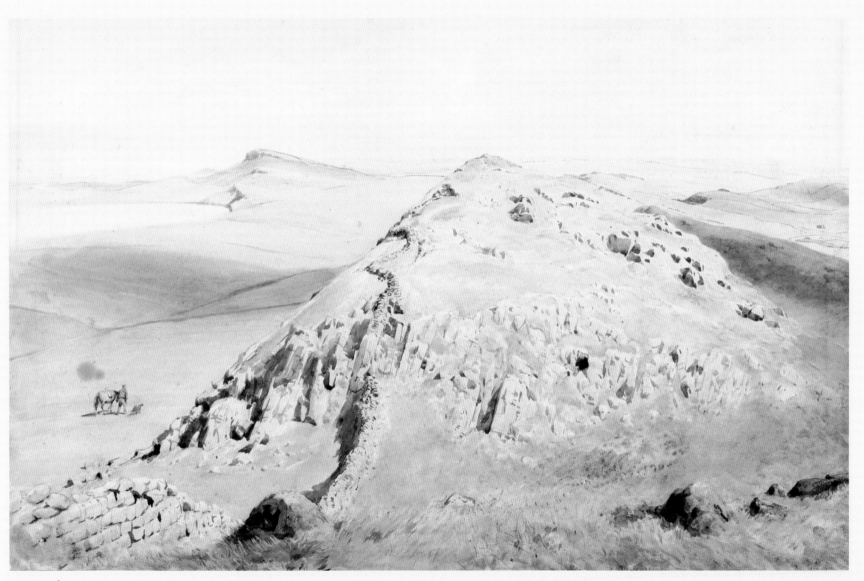

PLATE 36

Crag Lough

Henry Burdon Richardson

*'Crag-Lough. The Wall in its course
westward traverses the height above the lake.'*

Bruce only included the engraving of Crag Lough in his second edition, providing a brief comment, 'As we approach it [Milking Gap], Crag Lake [*sic*] is seen laving [washing] the base of the perpendicular cliffs along which the Wall runs' (Bruce 1867, 208).

This is one of the most spectacular views of the Wall striding over the crags west of Hotbank Crags, which lie to the west of Housesteads. The lough is one of the four lakes in this part of Hadrian's Wall. The cliffs today are a favourite haunt of rock climbers.

References: Bruce 1853 facing p. 202; Bruce 1863, 143; Bruce 1884, 154;
Bruce 1885, 165 (woodcuts in the *Handbooks*); *Drawings* No. 24.
Laing G10343.

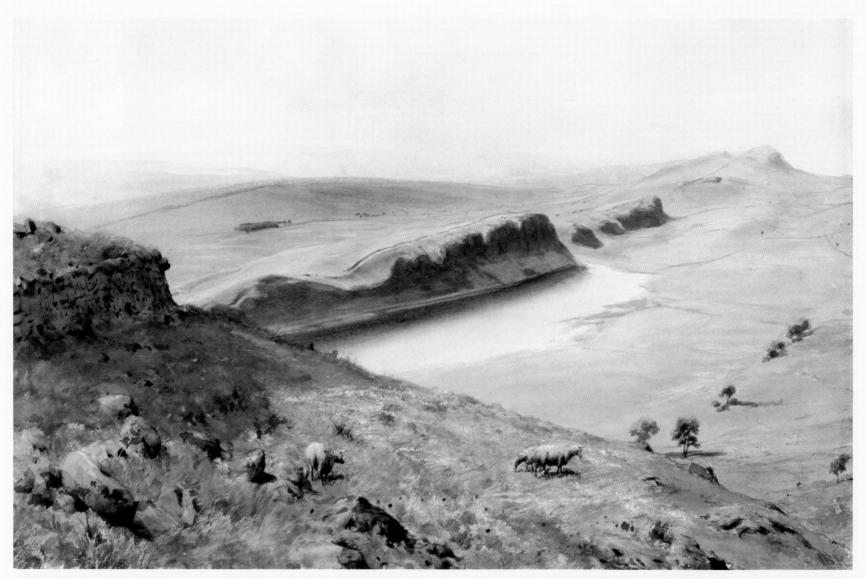

PLATE 37

The crag at the
west end of Crag Lough
Henry Burdon Richardson

*'The crag at the west end of Crag-Lough; the root [core] of the Wall
is on the top of it.'*

This depicts well the precipitous cliffs to the north of the Wall. They form
an excellent location for the Wall, though an artificial barrier hardly seems
necessary on top of such a strong natural defence. This is reflected in the
late construction of this part of the Wall.

Reference: *Drawings* No. 26.
Laing G10324.

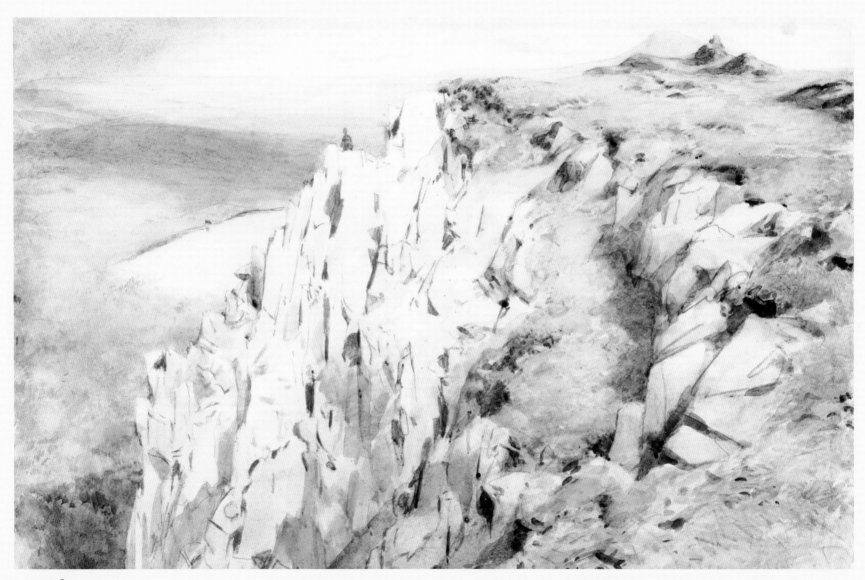

PLATE 38

Crag Lough and the Roman Wall
Thomas Miles Richardson junior

This view of Crag Lough looking eastwards is by Thomas Miles Richardson jun. and is undated. It is similar in its viewpoint to those of his brother Henry, but is an entirely different style. In many ways it is more informative, as it shows the wall in the foreground and then climbing onto Highshield Crags. After dropping into Milking Gap, the site of a rural settlement of the Roman period, it can be seen climbing Hotbank Crags. Hotbank Farm is visible; to its right, but not visible, lie the remains of MC 38 (Hotbank) which has yielded two inscriptions recording its construction by soldiers of the Second Legion under the Emperor Hadrian and the governor A. Platorius Nepos.

Laing E3548.

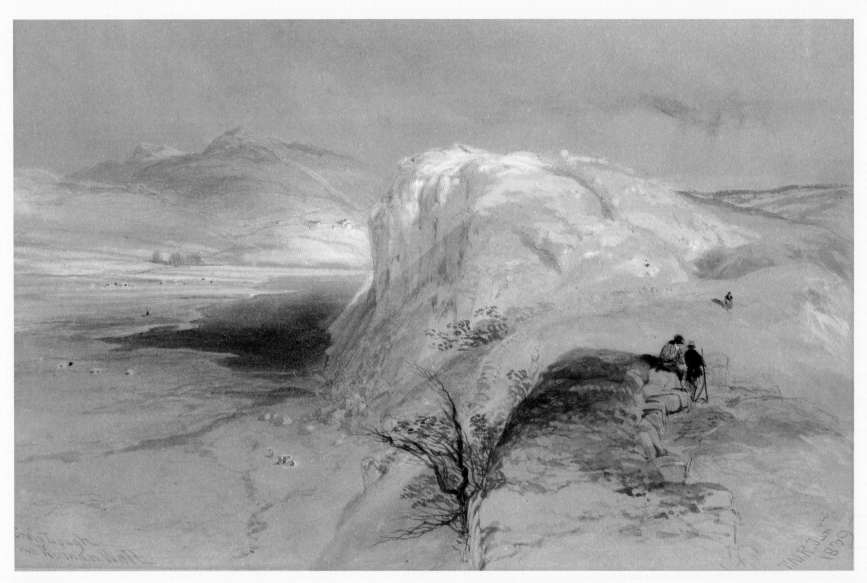

PLATE 39

Steel Rigg looking east
Henry Burdon Richardson

'*The Wall at Steel-Rigg, looking east. Viewed from the north.*'

The wall here is negotiating one of the small gaps along its line and in this location, as in several other gaps, it stands several courses high. At the bottom of the cliffs lies Crag Lough.

References: *Drawings* No. 31 (also 31a).
Laing G10327.

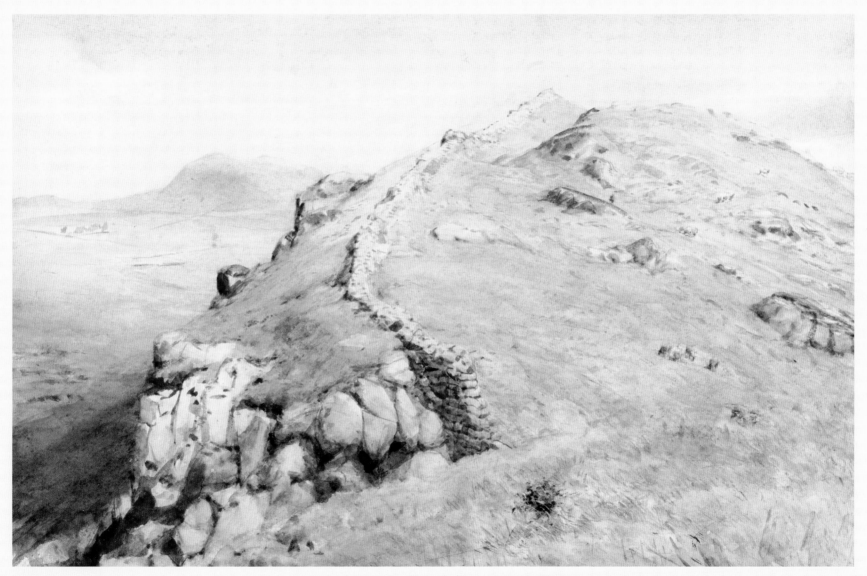

PLATE 40

Steel Rigg grounds

Henry Burdon Richardson

'The Wall, as it climbs, in an easterly direction,
the Steel-Rigg grounds. Viewed from the south.'

This is the gap between Milking Gap and the newly-named Sycamore Gap. Bruce used the view to describe the construction of the Wall; on the eastern side of the pass 'the courses are laid parallel to the horizon; the mortar of each course of the interior seems to have been smoothed over before the superincumbent mass was added' (Bruce 1867, 225). Where the slope is less steep, the courses follow the lie of the land.

References: Bruce 1851, facing p. 244; Bruce 1853, facing p. 35;
Bruce 1867, facing p. 225; *Views*; *Drawings* No. 30.
Laing G10325.

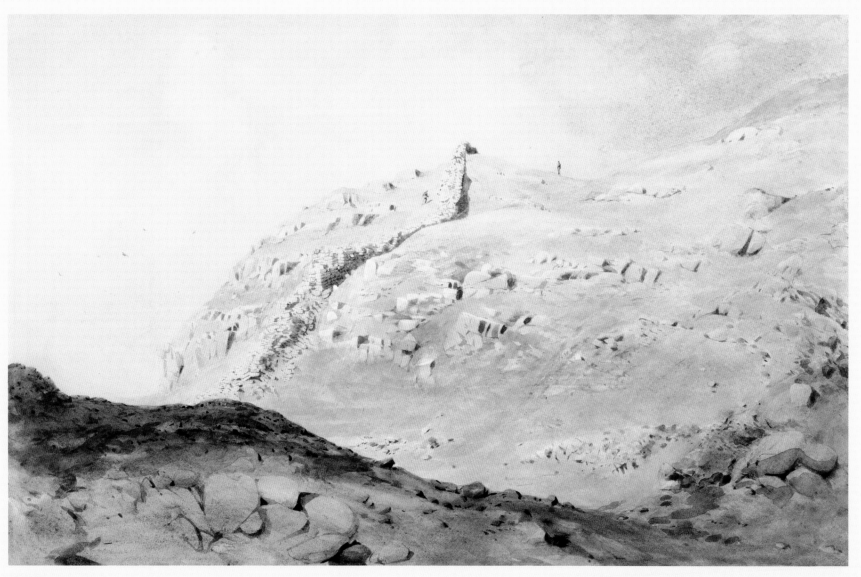

PLATE 41

Castle Nick milecastle

Henry Burdon Richardson

———————

'The remains of the Mile-castle at Castle-Nick. The Wall is seen running eastward along the edge of the cliffs, at the foot of which is Crag-Lough.'

This milecastle was, 'in 1854, freed from its encumbering rubbish by Mr. Clayton'. Bruce described the walls and provides measurements, and then went on to say, 'the chief peculiarity of this castle is, that the foundations of the interior apartments of the building still remain, on the western side. The erections have been independent of the main walls, and have been more rudely constructed' (Bruce 1867, 225–6). The painting shows the excavation trench round the inside of the east and north walls. Bruce stated that the 'lithographic view' was 'taken from a sketch by Mr Henry Richardson'.

The milecastle was subsequently re-examined in 1908–11 and re-excavated by Jim Crow in 1985–7. The plan of the milecastle shows that it was one of only a few completely built to the Narrow Wall specifications, therefore late in the building programme. Occupation was found to continue into the fourth century.

———————

References: Bruce 1863, 153 (woodcut); Bruce 1867, 72 (woodcut) and facing p. 226 (unacknowledged; engraved by Kell); Bruce 1884, 162; Bruce 1885, 173 (woodcuts); *Drawings* No. 34. Laing G3875.

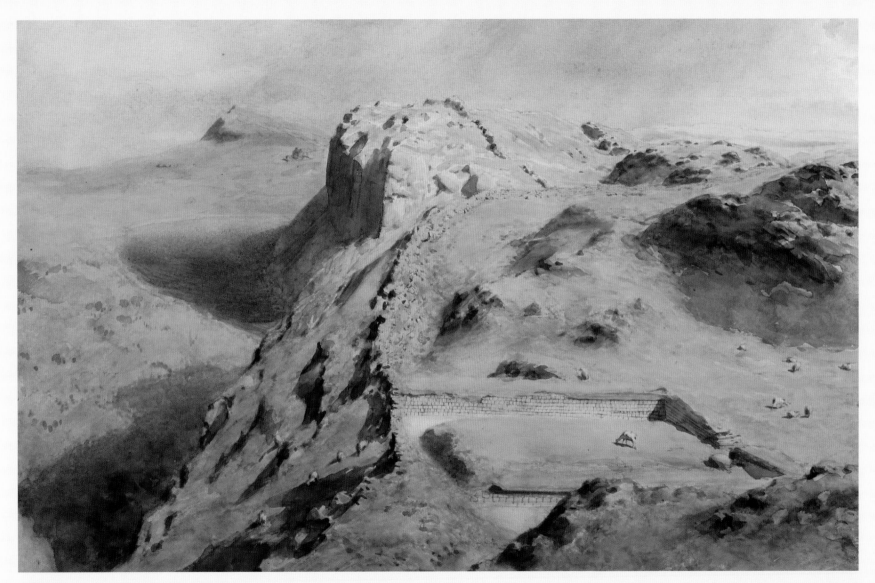

PLATE 42

The Vallum at Castle Nick

Henry Burdon Richardson

'The Vallum a little to the east of Castle-Nick.'

This shows the Vallum as it proceeds westward. The south mound lies to the left, with the ditch and the north mound to the right. There is also a hint of the presence of a marginal mound on the south lip of the ditch. This is a secondary feature, probably dating to the return from the Antonine Wall in the 150s or shortly afterwards, and appears to have been intended to restate the original purpose of the Vallum, that is, an obstacle to movement. It is not clear where the soil came from to create the marginal mound, but some was probably from the ditch.

Reference: *Drawings* No. 33.
Laing G10328.

PLATE 43

The milestone at Chesterholm

Henry Burdon Richardson

'A Roman mile-stone near the station of Chesterholm;
the platform of the station of VINDOLANA [sic], *Chesterholm,*
is seen in the background.'

This milestone still stands in the shadow of the fort and civil settlement at Vindolanda beside the Stanegate. Bruce acknowledged the presence of 'traces of an inscription on its western face, but scarcely a letter can now be deciphered' (Bruce 1851, 239). There is the stump of a second milestone a mile to the west along the Stanegate, a unique occurrence in Roman Britain. The fort at Vindolanda has been excavated, together with its bath-houses and adjacent civil settlement, by the Vindolanda Trust, with the finds on display in the site museum, and replicas of a turret and milecastle gate completing the ensemble. The fort is perhaps most famous for the discovery of the Vindolanda writing tablets, but the range of material on display in the museum is breath-taking.

References: Bruce 1851, facing p. 239; Bruce 1853, facing p. 207;
Bruce 1867, facing p 223; *Views*; *Drawings* No. 29.
Laing G10323.

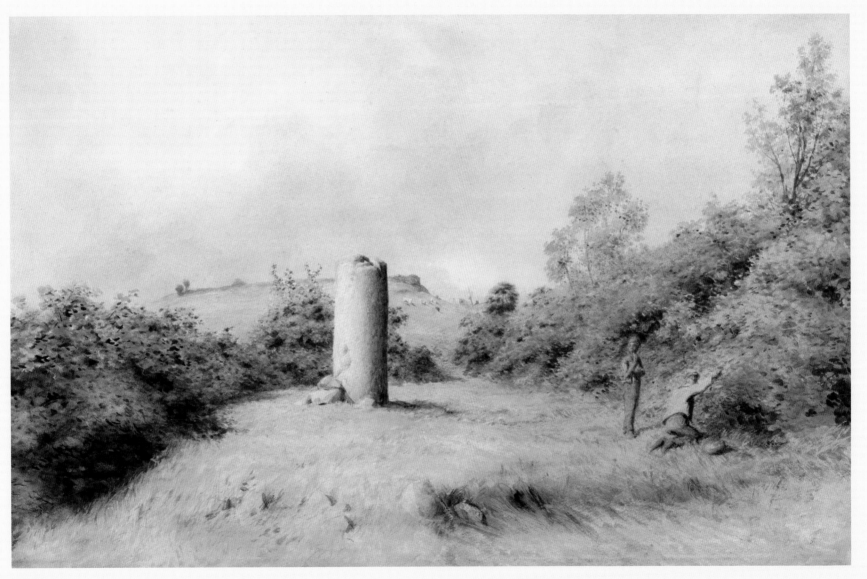

PLATE 44

Cats' Stairs

Henry Burdon Richardson

*'The Cats' Stairs on the north of the Wall between
Peel-Crag and Crag-Loiugh. Small sepia drawing.'*

This was not published as a full-page illustration, but only as a woodcut
(and in a very exaggerated style), which is unfortunate because it is an
interesting view looking at the Wall in a gap in the crags, showing masonry
still standing several courses high.

References: Bruce 1863, 151; Bruce 1884 163 (woodcut); *Drawings* No. 57.
Laing G3877.

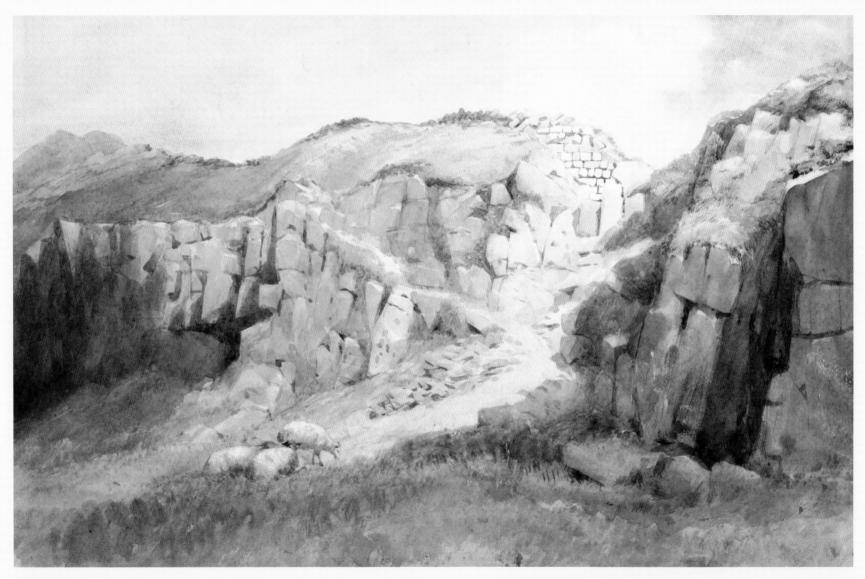

PLATE 45

Steel Rigg looking west
Henry Burdon Richardson

'The Wall sinking into the hollow at Steel-Rigg,
and thence proceeding westwards'

It is interesting to see how much of the Wall was visible in 1848. John Clayton set his workmen to replace the fallen facing-stones so that the Wall often looks better preserved today than it did in 1848. These stones of the 'Clayton Wall' are back pointed so that it appears as if they have simply been placed one on top of the other. Here, on this steep slope, the courses do not follow the contours but are stepped down the hillside.

Reference: *Drawings* No. 32.
Laing G3874.

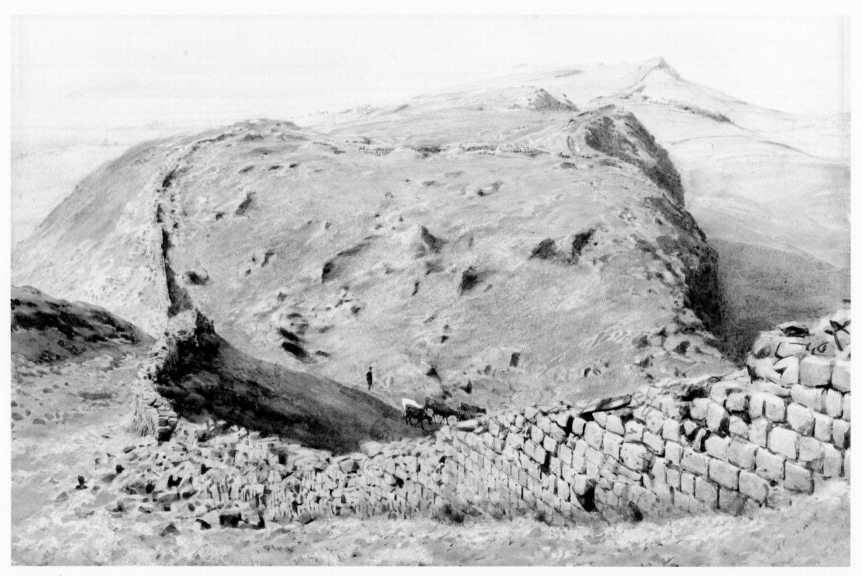

PLATE 46

Winshields Crags

Henry Burdon Richardson

———————

'The Wall passing over Winshields Crags (the highest part of its course),
going eastward. Crag Lough, Greenlee Lough, Broomlee Lough, and the
farm-house of Hot Bank are seen in the distance. A large drawing.'

The painting appears to be missing, but the engraving by Storey appearing
in Bruce (1867, between pp. 228 and 229) is reproduced in its place.

———————

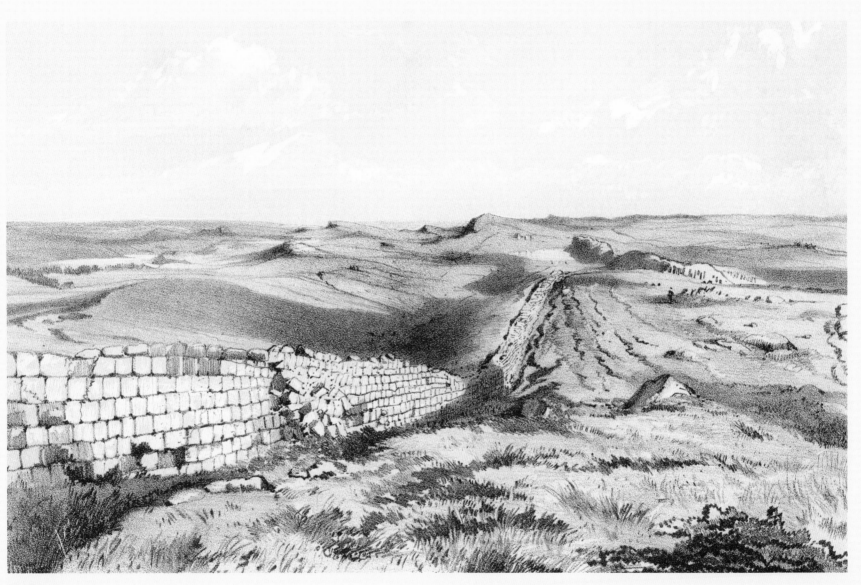

PLATE 47

Shield-on-the-Wall

Henry Burdon Richardson

*'The Wall as it passes Shield-on-the-Wall and proceeds to
Cockmount Hill. The Vallum is to the south of the cottages, which,
since the taking of the sketch, have been dismantled.'*

In his brief comment on this site in 1867 Bruce recorded that the 'thatched
cottage . . . is about to be removed' (Bruce 1867, 228). The new farm was
built south of the Vallum and for a time was referred to as Shield off the
Wall. Clayton removed several farms and cottages from the line of the
Wall and replaced them with high-quality farmhouses nearby (Woodside
and Crow 1999, 122). In this case, the farm sat beside MC 41 which had
been used as an allotment. The field wall to the right sits on top of
Hadrian's Wall, as it so often does; in several places the Wall and its succes-
sor field wall form a parish or estate boundary. To its right, the Wall ditch
may be seen.

Reference: *Drawings* No. 36.
Laing G10344.

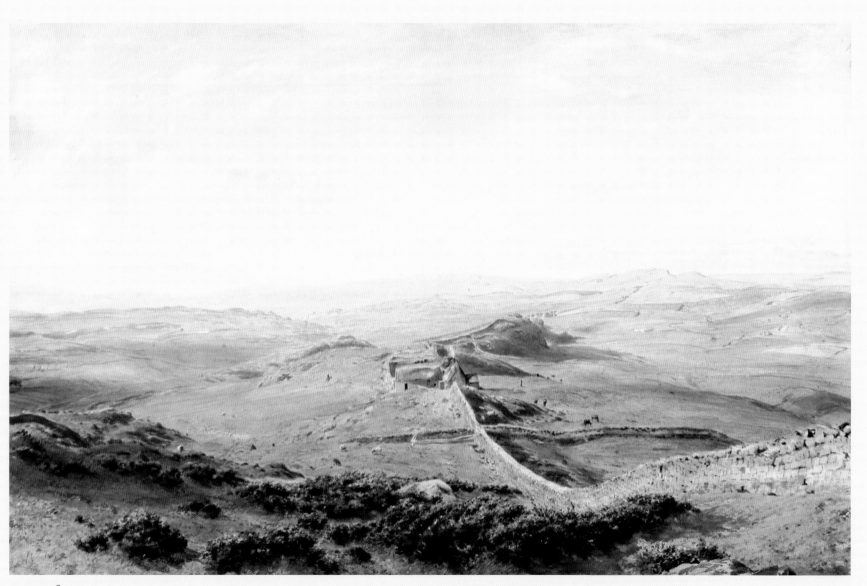

PLATE 48

Caw Gap

Henry Burdon Richardson

'Caw-Gap; the fosse [ditch] of the Wall.
The cottages are now in ruins.'

Bruce wrote expressively of the line of the Wall here: 'the extreme jealousy with which the Romans defended an exposed situation is well shewn here. The fosse, which guards the pass through the low ground, is discontinued on the western side as soon as the Wall attains sufficient elevation, but upon the ground dropping, though only for the space of a few yards, it re-appears for that short distance' (Bruce 1851, 246). This is an excellent description, but the implication that the Wall was being defended by an army on a wall-walk is a different matter. It is possible to accept that the line of the Wall here is merely responding to the necessity to negotiate the wide gap, following the contours by diverting to the south rather than plunging down and up precipitous slopes.

Reference: *Drawings* No. 37.
Laing G10329.

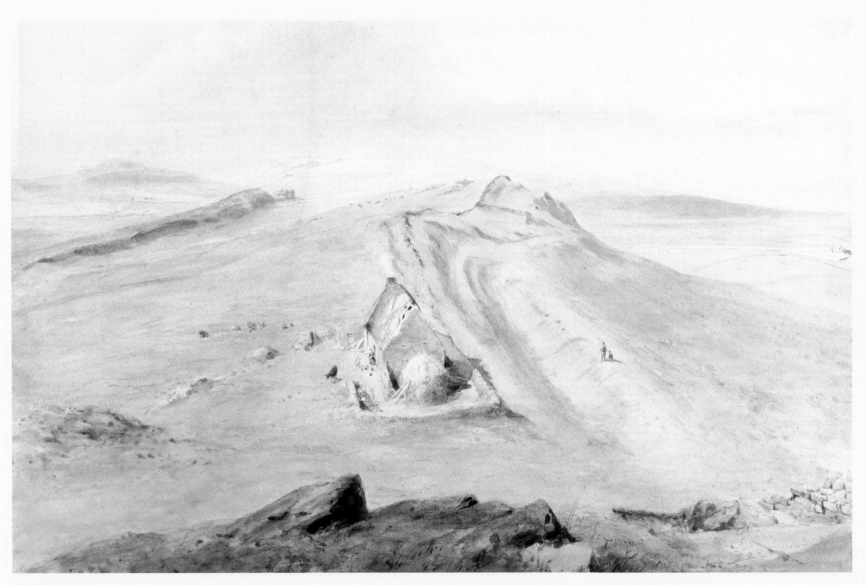

PLATE 49

The milecastle at Cawfields

Henry Burdon Richardson

'The Mile-castle at Cawfields when in the course of excavation.'

MC 42 (Cawfields) by John Storey.

'Until recently, the castellum was nearly covered with its own ruins' (Bruce 1851, 248). Indeed, it was the year before Bruce visited that John Clayton had his workmen clear away the debris from the milecastle following his recent purchase of the land. Henry Richardson's painting is remarkable therefore in showing the milecastle in its newly cleared state, the equivalent of an excavation photograph. The south gate is clearly visible, the northern one less so. The engraving published three years later (the image on the left) shows a further detail, the point of junction between the north wall of the milecastle and Hadrian's Wall, as well as the cleared wall running up the slope to the west of the milecastle.

References: Bruce 1851, facing p. 248; Bruce 1853, facing p. 217;
Bruce 1867, facing p. 230; *Views*; *Drawings* No. 39.
Laing G3397.

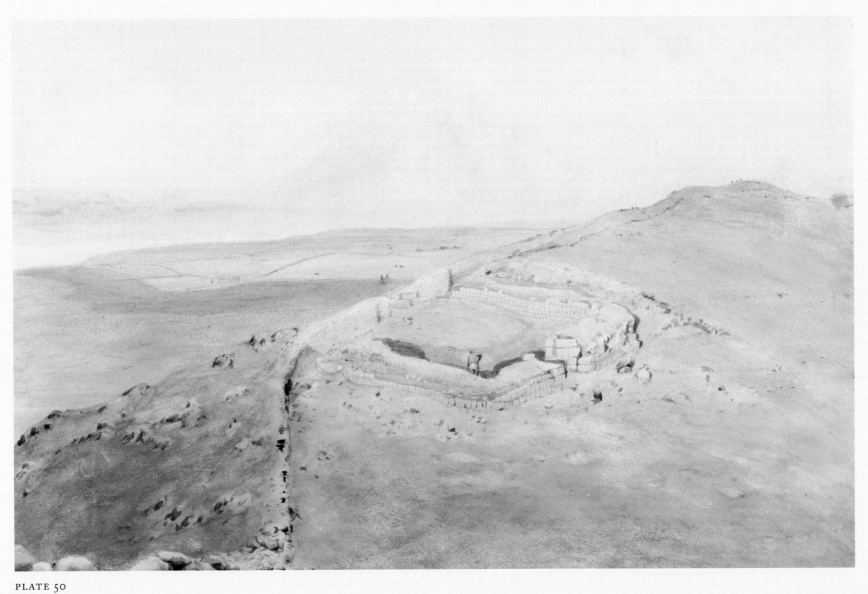

PLATE 50

The south gate at Cawfields milecastle

Henry Burdon Richardson

*'South gateway of the Mile-castle at
Cawfields. A small sepia drawing.'*

The masonry of this gate is massive in its scale, similar to that at MC 37 (Housesteads) and presumably constructed by the same legion, the Second. The gate has a special interest, unfortunately not visible on this view. Bruce noted that 'two folding-doors have closed the entrance, which, when thrown back, have fallen into recesses prepared for them' (Bruce 1851, 249). It may still be observed that the reduction in the thickness of the side walls of the milecastle from a proposed 10 Roman feet to 8 Roman feet resulted in the width of the southern gate passage being narrowed. The western recess was now not quite long enough to receive the full width of the gate when open so the stonework of the rear pier had to be cut back. No buildings were recorded within the milecastle; they are likely to have been removed by those clearing its interior. Visitors have always been puzzled at how any buildings might have been arranged on the steep slope.

Reference: *Drawings* No. 56.
Laing G3876.

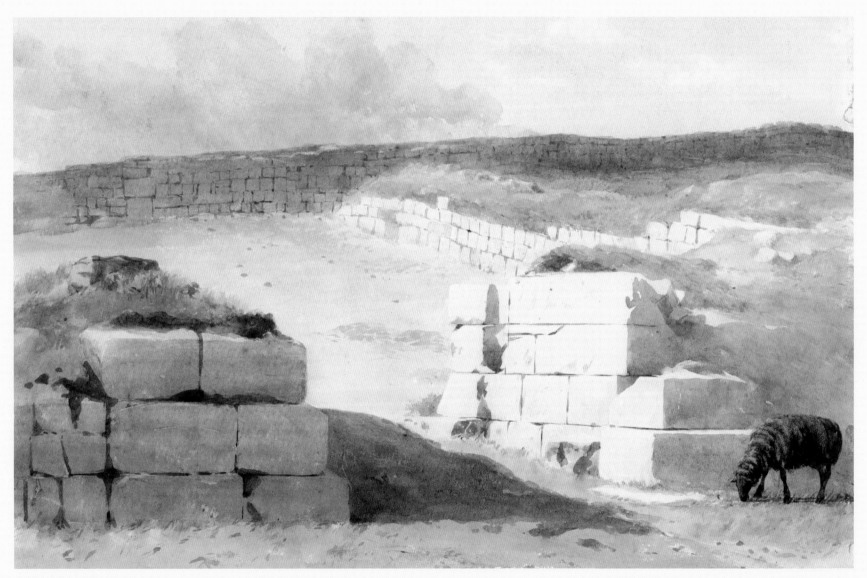

PLATE 51

The south gate at Cawfields milecastle
Henry Burdon Richardson

————————

*'The south gateway of the Cawfields Mile-castle. The
Wall is seen in its course westward. In the background is the
military-way and the road leading to Haltwhistle.'*

This shows the south gate from the north, with the Wall striding
westwards up the hill to the right. Today, it abruptly terminates on top of
the rise where it is cut off by the now-defunct Cawfields quarry.

————————

Reference: *Drawings* No. 40.
Laing G10338.

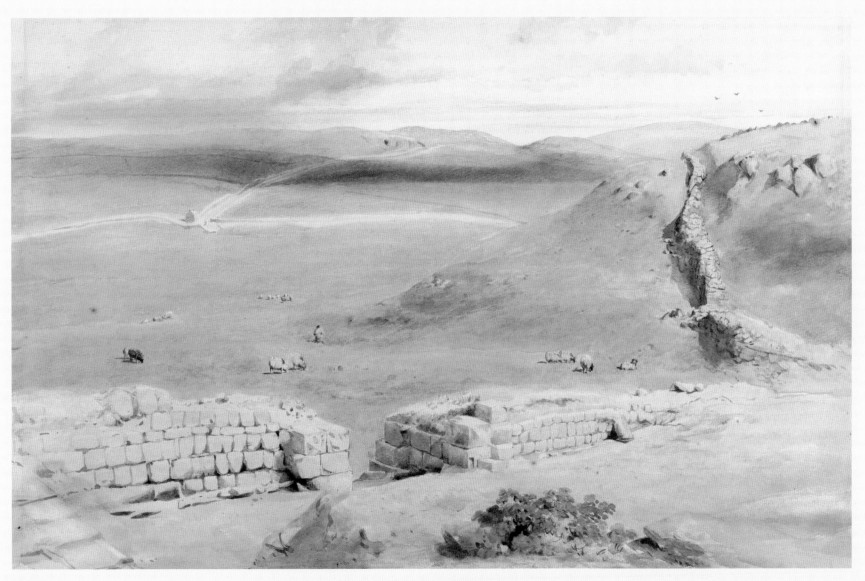

PLATE 52

The Vallum at Cawfields

Henry Burdon Richardson

*'The aggers [mounds] of the Vallum, near Cawfields,
proceeding eastward; the Wall has occupied the heights on the left.'*

Bruce included the engraving in his magisterial third edition of *The Roman Wall* as the focal point of a discussion of the Vallum. He recorded 'the opinion of Anthony Place, an intelligent workman in the employment of Mr Clayton' that the ditch of the Vallum was about seven feet (2.13 m) deep (Bruce 1867, 57). Bruce went on to ask 'whence were the materials obtained for constructing the mounds of the Vallum?' He presumed the ditch, but stated that this 'would not yield materials sufficient for the purpose'. He suggested some material from the Wall ditch may have been used, and acknowledged that this would depend upon the two elements of the Wall being contemporary. The source of the earth used in some elements of the Vallum remains a problem. Bruce noted that there were no breaks in the Vallum (actually there are), and therefore argued that its purpose was 'to prevent a sudden attack from behind' (Bruce 1867, 58). This remains a magnificent stretch of the Vallum, and the painting shows clearly the later marginal mound sitting on the southern lip of the ditch.

References: Bruce 1867, facing p. 57 (unacknowledged); *Drawings* No. 38.
Laing G10330

PLATE 53

The Wall on Cockmount Hill

Henry Burdon Richardson

───────────

'The Wall as it is seen on Cockmount Hill, to the east [west] of the station of ÆSICA. Viewed from the north.'

This view is wrongly described as being to the east of Aesica, the Roman name of the fort at Great Chesters, in the 1886 list; it was corrected in the later catalogue.

'For some distance' after Great Chesters fort, said Bruce, 'little more than the foundation courses remain in position. The fosse, which at first is distinct, is soon discontinued. After passing Cockmount farm-house, we meet with a long and very encouraging tract of the Wall. Its north face exhibits six or seven courses of facing stones, and in some places as many as nine; the south face is broken. The lithograph drawing [shown here] represents it' (Bruce 1867, 239).

Alas, the Wall is no longer in this condition. This stretch is now a pile of grass- and moss-covered stones with the view to the north and to the east blocked by a plantation of fir trees.

───────────

References: Bruce 1867, facing 239 (lithograph by Kell); *Drawings* No. 41.
Laing G3398.

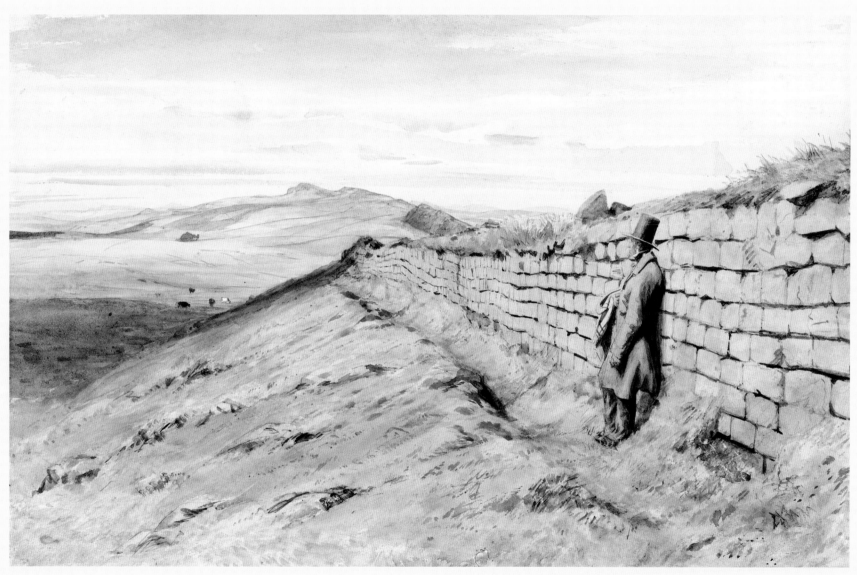

PLATE 54

Cockmount Hill

Henry Burdon Richardson

'Cockmount Hill and the east end of the Walltown Crags,
as viewed from the south. The outcrop of the strata in the foreground
has been utilised by being constituted a part of the Vallum.'

'Shortly after leaving Æsica, the crags again appear, and the Wall ascends the heights' (Bruce 1851, 263). Here, the Wall passes Cockmount Hill – to the right – and runs along the Nine Nicks of Thirlwall heading for Walltown. The Vallum in this area was the scene of an important excavation which revealed that only five to fifteen years had passed before the earthworks were slighted by throwing crossings over the ditch and creating gaps in the mounds. This is believed to have occurred when the Antonine Wall was built in the 140s and Hadrian's Wall abandoned.

Reference: *Drawings* No. 42.
Laing G10332.

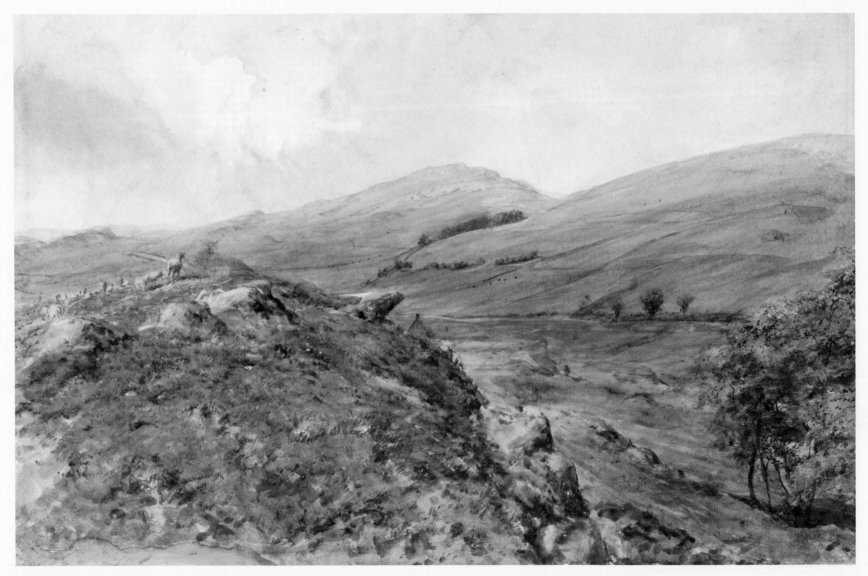

PLATE 55

The Nine Nicks of Thirlwall

Henry Burdon Richardson

*'The Wall as it is seen going eastward
over the Nine Nicks of Thirlwall.'*

Walltown crags painted by an
anonymous traveller in 1851.

'The mural ridge, divided by frequent breaks into as many isolated crags, is denominated by the Nine Nicks of Thirlwall. The view from the edge of the cliff is extensive; stunted trees unite with the craggy character of the rock in giving variety to the foreground. The Wall adheres, with tolerable tenacity, to the edge of the crags, and hence pursues a course that is by no means direct' (Bruce 1851, 265). The striking landscape coupled with the good survival of the Wall here resulted in several drawings and paintings of this stretch. Some survive from about this time (Roach Smith 1852; Breeze 2015) demonstrating, as does this painting, how much of the Wall was visible at that date. This is particularly valuable as subsequent quarrying has removed sections of the Wall here.

Reference: *Drawings* No. 43.
Laing G10335.

PLATE 56

Gilsland

Henry Burdon Richardson

*'A view taken north of the Wall, near Gilsland, showing
in the background the Nine Nicks of Thirlwall.'*

It is difficult to identify this view today as a result of later developments in the area. Gilsland was the scene of an important excavation in 1909 when MC 48 (Poltross Burn) was completely excavated, and a chronology for the history of the Wall laid down. The milecastle is open to the public, as are the two turrets and milecastle to the west, this being the only mile along the Wall where all structures are visible.

Reference: *Drawings* No. 44.
Laing G10334.

PLATE 57

Harrow's Scar

Henry Burdon Richardson

'The Cliff up which the Wall is believed to have ascended,
after crossing the river Irthing, on its way to Birdoswald.'

Bruce the Pilgrim was clearly tested at this point: 'the western bank of the river [Irthing] is lofty and precipitous. Consisting, as it does, chiefly of diluvial soil and gravel, on which the water of the stream below is continually acting, it is not surprising that all traces of the Wall, if it ever ascended the height, have long since disappeared. On the very brink of the precipice above, the remains of the Wall and fosse re-appear. The faithful followers of the Wall, who have closely pursued its track from the eastern sea, will not be willing to desert their companion, even for a brief space, at this point. The cliff, however, will test their constancy' (Bruce 1851, 277).

Bidwell and Holbrook (1989, plate 6) noted that the painting showed 'the Wall and Wall ditch being undermined by the River Irthing', and suggested that the 'large blocks in the river may represent the disturbed remains of the western bridge abutments'. The east abutment of the bridge remains and reveals several phases of construction and reconstruction (Bidwell and Holbrook 1980, 50–98).

Reference: *Drawings*, No. 45.
Laing G3399.

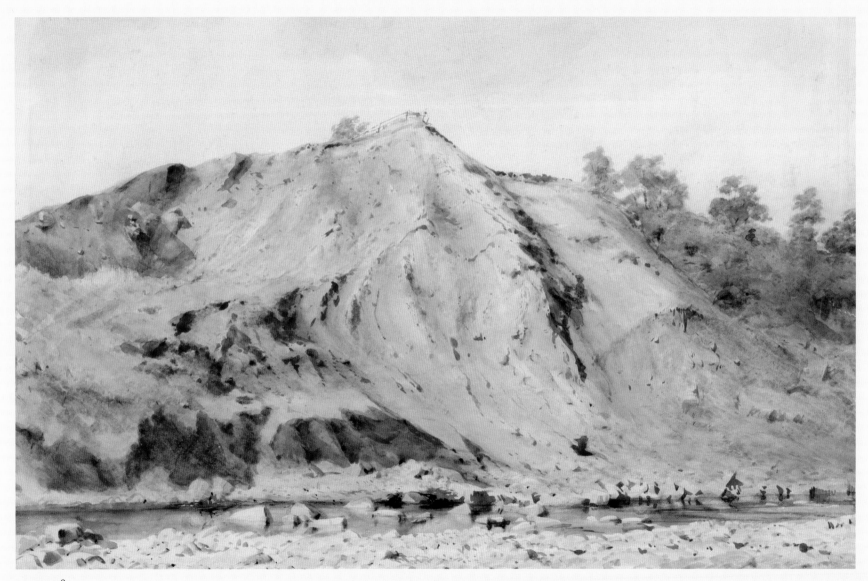

PLATE 58

Birdoswald fort

Henry Burdon Richardson

*'Birdoswald farm-house and the west rampart of the
station as they were in 1848. The gateway has since been cleared.'*

The west rampart and the minor side
gate by John Storey

Bruce observed that the 'accompanying lithograph ... well represents the chilly and somewhat forbidding aspect of this now nearly deserted place' (1851, 282). The wall and west gate visible in the foreground were cleared by the owner, Thomas Crawhall, in 1831, with the gate re-excavated by Henry Glasford Potter and the then owner Henry Norman twenty years later (Potter 1855, 64–6). Richardson's painting was undertaken during his visit in 1848, but when Storey came to prepare his engraving the entrance had been cleared of rubble with the result that it can be seen more clearly. As the excavation took place in September 1850, Storey's visit must have occurred in the following weeks but before *The Roman Wall* was printed at the end of the year (Potter 1855, 63).

In *Views*, Bruce noted the 'ruts, formed apparently by the action of wheeled carriages' in the gateway (Bruce 1867, 257). Ten years after this painting a tower was added to the western gable of the farmhouse to give it a Gothic appearance (Wilmott 2001, 159).

References: Bruce 1851, facing p. 282; Bruce 1853, facing p. 244;
Bruce 1867, facing p. 256; *Views*; *Drawings* No. 48.
Laing G10333.

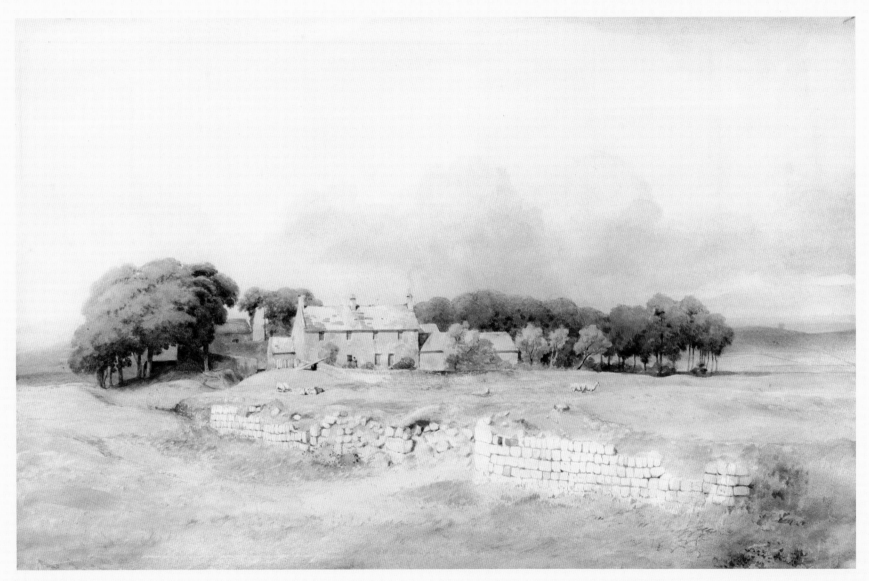

PLATE 59

The north-west corner of Birdoswald fort
Henry Burdon Richardson

'The north-west angle of the station of Birdoswald
showing its connection with the Wall as seen in 1848.'

Bruce commented on the depiction of the north-west corner of the fort, 'the station is entirely independent of the Wall and must have been built before it', as was indeed the case (Bruce 1851, 280). But he then came to a false conclusion, 'probably the first step taken in the construction of the Barrier, in every case, was the erection of the stationary camps', that is the forts. It was to be another eighty years before the complex relationships between the Wall and the forts was elucidated. At Birdoswald, excavation has revealed a complicated sequence. The Turf Wall was first built across the site. A section was then removed and the ditch filled in so that a fort could be placed astride the wall. Finally, a longer stretch of the Turf Wall was demolished and the replacement Stone Wall swung a little further north to meet the north-east and north-west corners of the fort, thereby providing a little extra space on the plateau to the south. Bruce, in passing, noted that the gap at the north-west angle was modern having been recently cut in order to provide a new access to the farm.

References: Bruce 1851, 84; Bruce 1853, 245; Bruce 1863, 177; Bruce 1867, 256; Bruce 1884, 176; Bruce 1885, 198 (all woodcuts); *Views, Drawings* No. 47. Laing G10348.

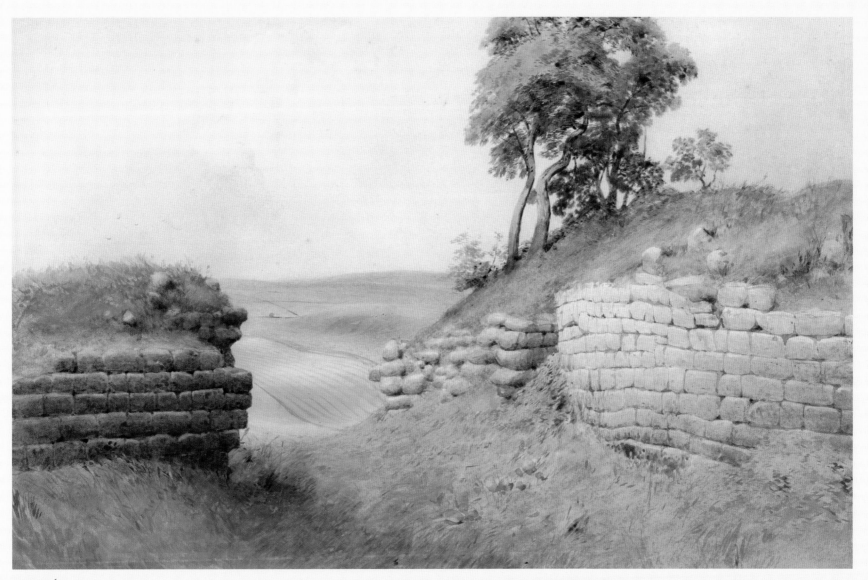

PLATE 60

The south gate at Birdoswald
Henry Burdon Richardson

———

When Bruce first visited Birdoswald he noted that the 'southern gateway may be discerned, though it is encumbered with rubbish' (Bruce 1851, 280). It was shortly afterwards cleared by Henry Glasford Potter (1855, 69–75) so that Bruce was able to remark that the 'southern gateway is a double one, and is a very noble specimen of Roman masonry. . . . It is divided into two portals, by columns of stone on its inner and outer margin, the bases of which only remain. . . . At some period subsequent to the building of the station, the western division of the gateway has been walled up and converted into a separate apartment' (Bruce 1853, 248). The blocking walls were removed in 1851, but the remains of two ovens survive in the eastern tower.

———

Reference: Bruce 1853, facing p. 247.

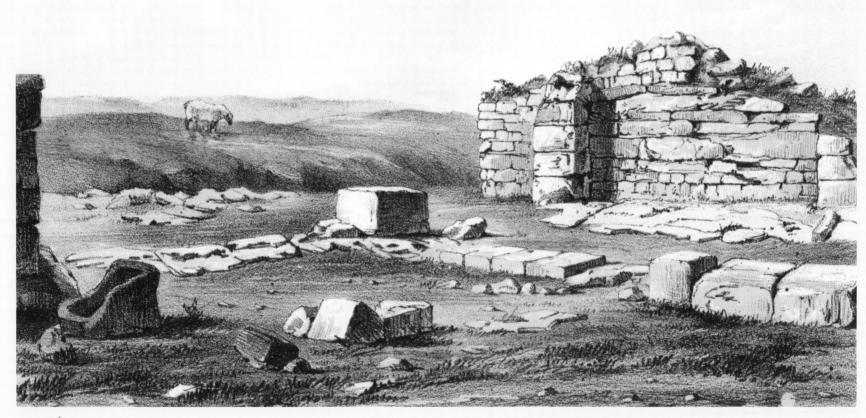

PLATE 61

The east rampart of Birdoswald

Charles Richardson

This painting is apparently of a random section of the east fort wall. It shows the fort wall between the east gate and the north-east corner, though the precise location cannot now be identified. On top of the Roman wall sits a modern field wall, later removed.

Laing 1994.555.

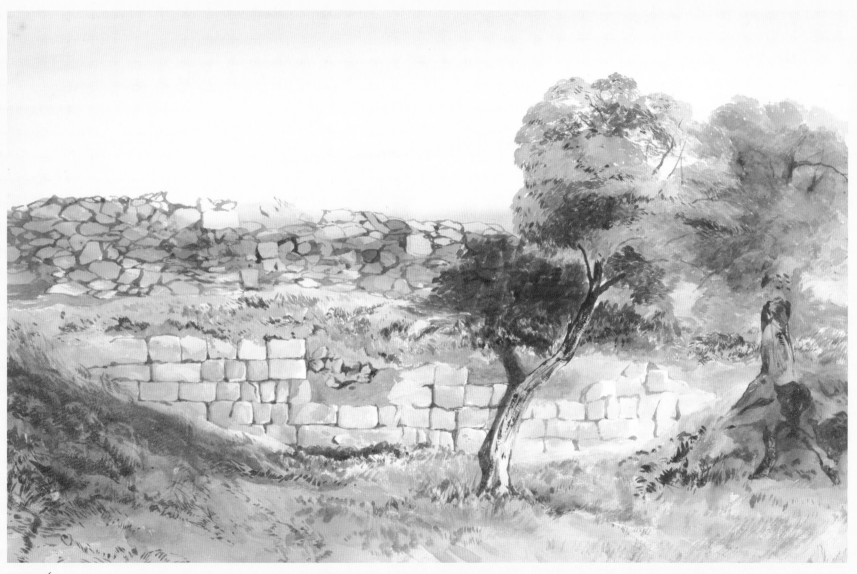

PLATE 62

The Irthing at Birdoswald

Henry Burdon Richardson

*'A view of the meanderings of the river Irthing in the vicinity of
Birdoswald. The station stands upon the principal height shown in the sketch.
See the Earl of Carlisle's "Diary on Turkish and Greek Waters," p. 87.'*

Bruce quoted with approval the Earl of Carlisle's comparison of this view of the river Irthing with the site of Troy; 'strikingly, and to anyone who has coasted the uniform shore of the Hellespont, and crossed the tame low plain of the Troad, unexpectedly lovely is this site of Troy, if Troy it was. I could give any Cumberland borderer the best notion of it, by telling him that it wonderfully resembles the view from the point just outside the Roman camp at Birdoswald. Both have that series of steep conical hills, with rock enough for wildness, and verdure enough for softness. Both have that bright trail of a river, creeping in and out with the most continuous indentations' (Bruce 1867, 253–4).

This remains a magnificent view but the river has eroded the bank; several excavations have taken place to record the archaeological deposits before they tumble into the river.

Reference: *Drawings* 46 (also 46a); a different version
by Kell appears in Bruce 1867, opposite p. 253.
Laing G10347.

PLATE 63

Beaumont

Henry Burdon Richardson

———

'The Wall as it approaches Beaumont (west of Carlisle);
its course may be discovered in the colour of the ground; the
valley of the Eden serves as its northern fosse [ditch].'

Bruce's comment on this section of the Wall is brief; 'leaving the village of Kirkandrews, the Wall strikes north-west in the direction of Beaumont; the Vallum goes in nearly a straight line to Monk Hall and Burgh-by-Sands' (Bruce 1867, 298). Earlier, he had remarked, 'the Wall proceeds, after its usual manner, from eminence to eminence' (Bruce 1851, 304).

No trace of the Wall is visible today. As Bruce remarked, there is no ditch provided where the Wall was close to the cliff edge, a phenomenon otherwise only observed in the crags sector.

In 1934, an inscription was found in the foundations of a wall of a cottage as it was being demolished. It was dedicated to Jupiter and recorded the name of the regiment stationed nearby at Burgh-by-Sands, a unit of Moors, originally therefore from north Africa. This prompted an article by Eric Birley pulling together all the evidence for the army units known to have been based on Hadrian's Wall (Birley 1939).

———

References: *Views*, *Drawings* No. 50.
Laing G10331.

PLATE 64

Burgh Marsh

Henry Burdon Richardson

'Burgh Marsh, on which stands King Edward's monument. Criffel in the distance.'

There is little for the student of Hadrian's Wall to see at Burgh as the fort lies under the village. Bruce spiced up his account with the information that it was 'the site of the castle of Sir Hugh de Morville, one of the murderers of Thomas à Beckett', and a comment on Edward I, king of England, who died here in 1307 on his way to deal with his subject Robert Bruce who had just conducted a coup d'etat and proclaimed himself king of Scots (Bruce 1851, 306; 1854, 278). As Bruce remarked, 'on Burgh Marsh the "ruthless king" breathed his last. A monument, represented in the following wood-cut, marks the spot.'

The fort lies under the eastern end of the modern village of Burgh-by-Sands; the modern road rises a little as it enters the village at this point, reflecting the eastern defences of the fort. As a result of its location, excavations have been few in number. To the south of the fort lay an extra-mural settlement and beyond that two earlier forts.

References: Bruce 1853, 278; Bruce 1863, 212; Bruce 1867, 305; Bruce 1884, 219; Bruce 1885, 233 (all woodcuts); *Drawings* No. 51.
Laing G10336.

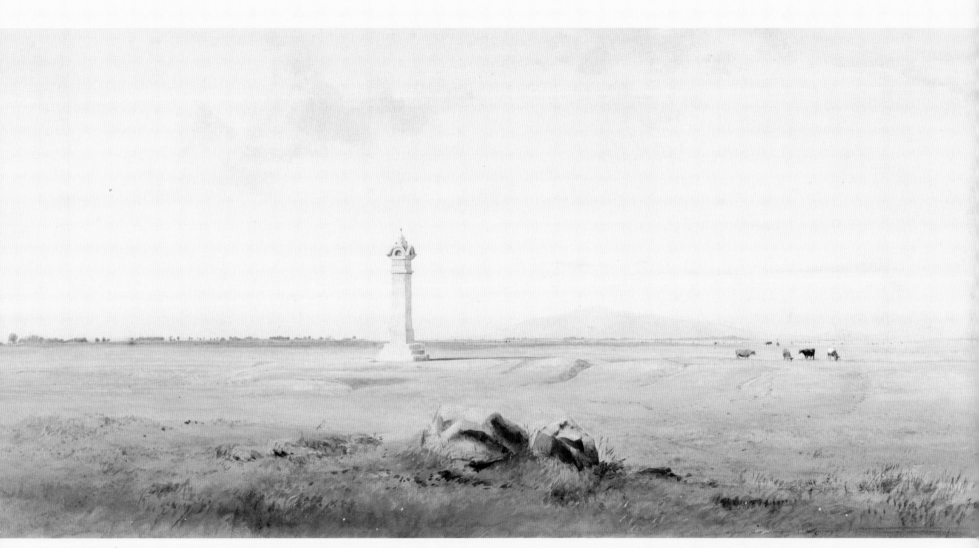

PLATE 65

Drumburgh

Henry Burdon Richardson

'Northern portion of the station of Drumburgh, as seen from the east.'

The Ilam Pan, one of three decorated small pans recording the names of some of the forts on Hadrian's Wall.

At the time of Bruce's visit, he recorded that 'the ramparts are well defined, as well as the ditch which surrounds them', however, 'no portion of the Wall remains in its vicinity, but its present proprietor remembers witnessing the removal of the foundation' (Bruce 1851, 309).

The fort sits on one of the low hills along the southern shore of the Solway Estuary, just to the west of the Solway Marshes where the line of the Wall is lost. It has twice been examined through excavation, in 1899 and 1947, but little is known about its history. It was originally provided with ramparts of turf, but these were later replaced in stone. In size, it was the smallest fort on the line of the Wall. The Ilam Pan, discovered in 2003, names the fort *Coggabata*.

Reference: *Drawings* No. 49.
Laing G10346.

PLATE 66

Bowness-on-Solway

Henry Burdon Richardson

'The Solway Firth as it laves [washes] the bank on which the north rampart of the station at Bowness was placed. Criffel is seen in the distance.'

Bruce noted that the fort 'is slightly elevated above the surrounding country, as is plainly seen when it is viewed from a distance. A little to the east of the site of the station, the Solway is easily fordable at low water; but no one, in the memory of the inhabitants of these parts, has forded the estuary westwards of the town. This circumstance would render Bowness a fit place at which to terminate the Barrier Wall' (Bruce 1851, 313). In *Views* Bruce stated that the view 'is taken from the spot where the northern rampart stood'. No remains of the fort are visible in the modern village of Bowness. The painting is lost and an engraving by Storey is reproduced here in its place.

This is indeed the western terminal fort on the Wall, but various installations – forts, milefortlets and towers – continued south-westwards down the Cumbria coast, though they were not connected by a linear barrier. One of the forts was at Maryport, where Bruce preached in 1830 and 1831 and visited again in 1870 when a cache of seventeen altars was discovered.

References: Bruce 1851, facing p. 313; Bruce 1853, facing p. 285; Bruce 1867, facing p. 305, *Views*; *Drawings* No. 52.

PLATE 67

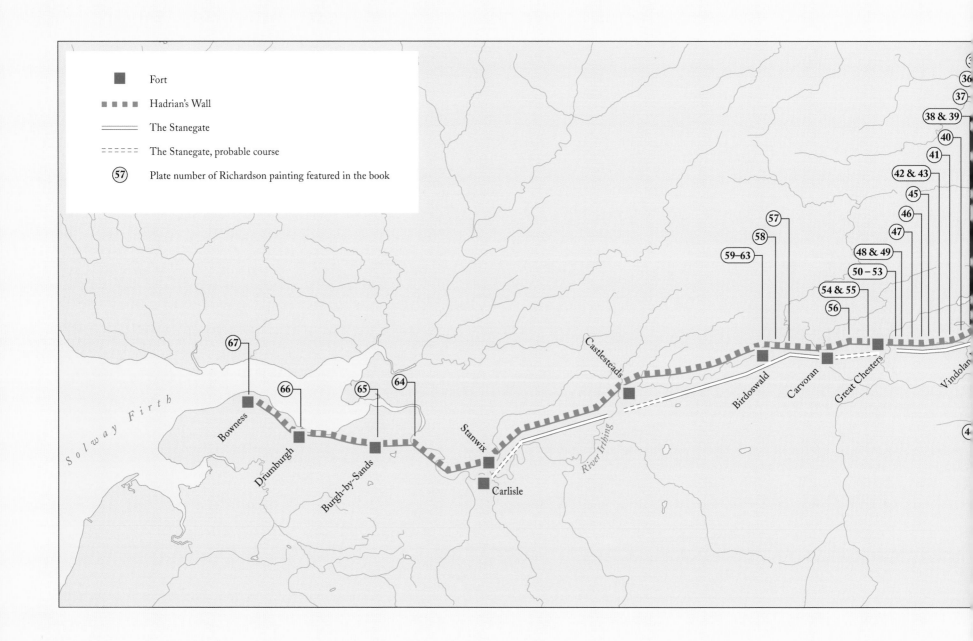

Fort

Hadrian's Wall

The Stanegate

The Stanegate, probable course

(57) Plate number of Richardson painting featured in the book

Solway Firth

Bowness

Drumburgh

Burgh-by-Sands

Stanwix

Carlisle

Castlesteads

River Irthing

Birdoswald

Carvoran

Great Chesters

Vindolan

36

37

38 & 39

40

41

42 & 43

45

46

47

48 & 49

50 – 53

54 & 55

56

57

58

59–63

64

65

66

67

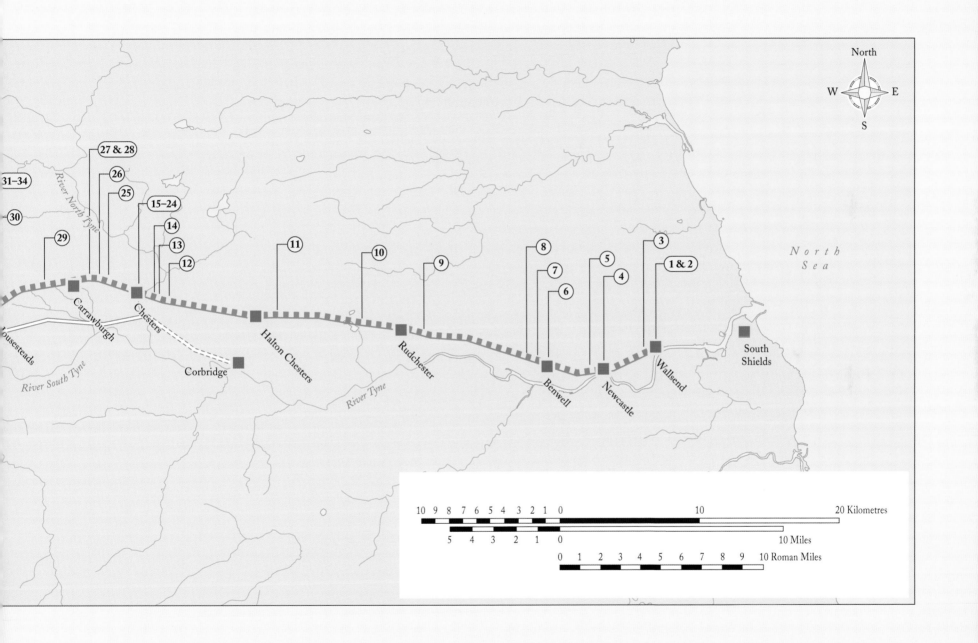

Appendix 1
The known paintings and their publication

The order of the paintings in the list below follows that of their presentation in the book.

Plate no.	Laing ref. no.	1886 list no.	1906 cat.	Name	HBR	CR	TMR	Used by Bruce	Engraver	Comment	Owner/ Occupier of site
1	G3852	1	✓	Wallsend looking west	✓+						N Tyneside /TWAM
2		58	✓	Wallsend looking east		✓		✓	Storey	Copy of 71	N Tyneside /TWAM
3	G3851	2	✓	Stote's Houses	✓+						
4		–		Pons-Aelii, Restored				✓•	Storey		
5	G3380	3	✓	Westgate Road, Newcastle	✓+						
6	G3381	4	✓	Benwell hill top	✓+						
7	G3382	5	✓	East Denton	✓+			✓	woodcut	Also by TMR sen	Newcastle
8	G3383	6	✓	Denton Hall	✓+						
9	G3384	7	✓	Heddon-on-the-Wall	✓+						EH
				Heddon-on-the-Wall		✓		✓•	Storey		EH
10	G3385	8	✓	Harlow Hill	✓+						
11	G3386	9	✓	Down Hill	✓+			✓•	Storey		
		72		Down Hill		✓				Sepia drawing	
12	G3391	10	✓	Brunton Bank	✓+						
13	G3387	11	✓	Brunton	✓+			✓•	Storey		EH
14	G3388	12	✓	Chesters bridge abutment	✓			✓	Kell	Only in 1867 edn	EH
	G10340	12a	✓	Chesters bridge	✓						EH
	G3392	12b	✓	Chesters bridge	✓						EH

+ painting undertaken in 1848
• painter acknowledged by Bruce

Key
Artist
HBR — Henry Burdon Richardson
CR — Charles Richardson
TMR — Thomas Miles Richardson junior

Owner/occupier
EH — English Heritage
GNM — Great North Museum
NT — National Trust
Newcastle — Newcastle City Council
N Tyneside — North Tyneside Council
TWAM — Tyne and Wear Archives and Museums
Vindolanda — Vindolanda Trust

Plate no.	Laing ref. no.	1886 list no.	1906 cat.	Name	HBR	CR	TMR	Used by Bruce	Engraver	Comment	Owner/Occupier of site
	G3390	12c	✓	Chesters bridge	✓						EH
15	G3870	13	✓	Chesters east gate	✓					Budge 1907, 101	EH
16	G3871	14	✓	Chesters hypocaust	✓+			✓•	Storey		EH
17		67		Chesters CO's house		✓				GNM	EH
18		68		Chesters CO's house		✓				GNM	EH
19		69		Chesters CO's house		✓				GNM	EH
20	G3854			Chesters bath-house		✓					EH
21	G10349			Chesters bath-house		✓					EH
22	G3855			Chesters bath-house		✓				Budge 1907, 108	EH
23	H12847			Chesters bath-house, hot bath		✓					EH
24				Chesters cemetery			✓	✓•	Storey		
25	G10319	15	✓	Tower Tye	✓+						
26	G5685	59	✓	Blackcarts turret (T 29a)	✓					woodcut based on Mossman	EH
				Limestone Corner: JCB and Gainsford							
27	G10320	17	✓	Limestone Corner ditch	✓+						
28	G10321	18	✓	Limestone Corner Vallum	✓+			✓•	Storey	1967 version by Kell	
	G3873	17a	✓	Limestone Corner Vallum	✓+						
	G3393	17b	✓	Limestone Corner Vallum	✓+						
29	G3396	19	✓	Sewingshields	✓+			✓•	Storey		
30	G10322	20	✓	Housesteads platform	✓+			✓	Storey	Newbald & Stead	NT/EH
31				Housesteads			✓	✓	woodcut	GNM	NT/EH
32	G3395	22	✓	Housesteads east gate	✓+			✓•	Altered by Storey		NT/EH
		70	✓	Housesteads east gate	✓					Large sepia drawing	NT/EH
33	G10342	21	✓	Housesteads north gate	✓			✓•	Not named		NT/EH
34	G3394	23	✓	Housesteads west gate	✓			✓	Kell	Only in 1867 edn	NT/EH
35	G10341	25	✓	Cuddy's Crag (MC 37)	✓			✓	Kell	Also Storey version	NT
36	G10326	27	✓	Rapishaw Gap	✓+			✓	woodcut		NT
37	G10343	24	✓	Crag Lough	✓+			✓•	Not named		NT
38	G10324	26	✓	West end of Crag Lough	✓+						NT
39	E3548			Crag Lough			✓				NT

Plate no.	Laing ref. no.	1886 list no.	1906 cat.	Name	HBR	CR	TMR	Used by Bruce	Engraver	Comment	Owner/ Occupier of site
40	G10327	31	✓	Steel Rigg looking east	✓+						NT
		31a	✓	Steel Rigg looking east	✓+						NT
41	G10325	30	✓	Steel Rigg grounds	✓+			✓•	Storey		NT
42	G3875	34	✓	Castle Nick milecastle (MC 39)	✓			✓	Kell	Only in 1867 edn	
43	G10328	33	✓	The Vallum at Castle Nick	✓+						
44	G10323	29	✓	Chesterholm milestone	✓+			✓•	Storey		Vindolanda/EH
45	G3877	57	✓	Cats' Stairs	✓+			✓	woodcut		NT
46	G3874	32	✓	Steel Rigg looking west	✓+						NT
47		35	✓	Winshields Crags	✓			✓	Storey	Drawing, now lost	
48	G10344	36	✓	Shield-on-the-Wall	✓+						NT
49	G10329	37	✓	Caw Gap	✓+						NT
50	G3397	39	✓	Cawfields milecastle (MC 42)	✓+			✓•	Storey	With new information	NT/EH
51	G3876	56	✓	Cawfields milecastle south gate	✓					Small sepia drawing	NT/EH
52	G10338	40	✓	Cawfields milecastle south gate	✓+						NT/EH
53	G10330	38	✓	Cawfields Vallum	✓+			✓	Kell	Only in 1867 edn	NT
54	G3398	41	✓	Cockmount Hill	✓+			✓	Kell		
55	G10332	42	✓	Cockmount/Walltown	✓+						
56	G10335	43	✓	Nine Nicks of Thirlwall	✓+						EH
57	G10334	44	✓	Gilsland	✓+						EH
58	G3399	45	✓	Harrow's Scar	✓+						EH
59	G10333	48	✓	Birdoswald fort	✓+			✓•	Storey		EH
60	G10348	47	✓	Birdoswald north-west angle	✓+			✓	woodcut		EH
61				Birdoswald south gate	✓			✓	not named		EH
62	1994.555			Birdoswald east rampart		✓					EH
63	G10347	46	✓	The Irthing at Birdoswald	✓+					Kell version different	
		46a	✓	River Irthing	✓						
64	G10331	50	✓	Beaumont	✓+						
65	G10336	51	✓	Burgh Marsh	✓+			✓	woodcut		
66	G10346	49	✓	Drumburgh	✓+						
67		52		Bowness-on-Solway	✓+			✓•	Storey		

+ painting undertaken in 1848
• painter acknowledged by Bruce

Key
Artist
HBR — Henry Burdon Richardson
CR — Charles Richardson
TMR — Thomas Miles Richardson junior

Owner/occupier
EH — English Heritage
GNM — Great North Museum
NT — National Trust
Newcastle — Newcastle City Council
N Tyneside — North Tyneside Council
TWAM — Tyne and Wear Archives and Museums
Vindolanda — Vindolanda Trust

Appendix 2
John Clayton, the paintings and Hadrian's Wall

Clayton's acquisitions		Excavation	Bruce's books
1832	inherited Chesters		
1834	Hotbank and Steel Rigg		
1838	Housesteads		
1843	onwards	Chesters CO's house • +	
1844	Cawfields +		
1847		MC 42 (Cawfields) • +	
1848	Shield-on-the-Wall		
1848–55		Chesters walls & gates • +	
1849–50		Housesteads fort • +	
1851	East Bog and Pasture House		*The Roman Wall, Views*
1853	Beggar Bog	MC 37 (Housesteads) • +	*The Roman Wall*[2]
1854		MC 39 (Castle Nick) •	
1857		MC 29 (Tower Tye)	
1860–3		Chesters Bridge Abutment • +	*The Wallet-book*
1863	Chesterholm (Vindolanda)		

Clayton's acquisitions		Excavation	Bruce's books
1867		Chesters east gate +	*The Roman Wall*[3]
1870		Chesters headquarters building +	
c.1870	Carrawburgh		
1871		Carrawburgh fort	
1873	East Cawfields	T 29a (Blackcarts) • +	
1874		Carrawburgh bath-house	*Lapidarium Septentrionale*
1876–7		Coventina's Well	
1878 and 80		T 26b (Brunton) +	
1879		Chesters south gate +	
1880–95		Chesters interior of fort +	
1883–4		Housesteads civil settlement +	
1883–6		T 45a (Walltown) +	
1884		MC 33 (Shield-on-the-Wall)	*The Hand-book*[2]
1885			*The Hand-book*[3]
1884–6		Chesters bath-house • +	
1885	Carvoran		
1886		Carvoran	

• Richardson painting
+ Site in the care of English Heritage

Further reading

Anon. nd *Drawings of the Roman Wall, with a description by the late J. Collingwood Bruce LLD DCL FSA*, Newcastle upon Tyne

Bidwell, P. T. 1997 'A water-colour of a culvert through Hadrian's Wall at West Denton, Newcastle upon Tyne', *Archaeologia Aeliana* 5th ser., 25, 151–2

Bidwell, P. T. 2005 'The system of obstacles on Hadrian's Wall: their extent, date and purpose', *Arbeia Journal* 8, 53–76

Bidwell, P. T. 2015 'The branch wall at Wallsend . . .', *Arbeia Journal* 10, 1–34

Bidwell, P. T. and Holbrook, N. 1989 *Hadrian's Wall Bridges*, London

Birley, E. 1939 'The Beaumont Inscription, the Notitia Dignitatum, and the Garrison of Hadrian's Wall', *Transactions of the Cumberland and Westmorland Antiquarian and Archaeological Society* 2nd ser, 39, 190–226

Birley, E. 1961 *Research on Hadrian's Wall*, Kendal

Blair, R. 1895 *The Hand-Book to the Roman Wall*, 4th edition, Newcastle upon Tyne

Breeze, D. J. 2003 'John Collingwood Bruce and the study of Hadrian's Wall', *Britannia* 34, 1–18

Breeze, D. J. 2006 *J. Collingwood Bruce's Handbook to the Roman Wall*, 14th edition, Newcastle upon Tyne

Breeze, D. J. 2007 'The Making of the *Handbook to the Roman Wall*', *Archaeologia Aeliana* 5th ser., 35, 1–10

Breeze, D. J. 2014 *Hadrian's Wall: A History of Archaeological Thought*, Kendal

Breeze, D. J. 2015 'Some nineteenth-century watercolours of Hadrian's Wall', *Archaeologia Aeliana* 5th ser., 44, 225–39

Brewis, Parker 1927 'Notes on the Roman Wall at Denton Bank, Great Hill and Heddon-on-the-Wall – Northumberland', *Archaeologia Aeliana* 4th ser., 4, 109–21

Bruce, G. 1905 *The Life and Letters of John Collingwood Bruce*, Edinburgh and London

Bruce, J. C. 1851 *The Roman Wall*, Newcastle upon Tyne

Bruce, J. C. 1851a [referenced throughout as *Views*] *Views on the line of the Roman Wall in the North of England*, London

Bruce, J. C. 1853 *The Roman Wall*, 2nd edition, London

Bruce, J. C. 1857 'Account of the excavation made at the Roman station of Bremenium during the summer of 1855', *Archaeologia Aeliana* 2nd ser., 1, 69–85

Bruce, J. C. 1863 *The Wallet-book of the Roman Wall*, Newcastle upon Tyne

Bruce, J. C. 1867 *The Roman Wall*, 3rd edition, London

Bruce, J. C. 1884 *The Hand-book to the Roman Wall*, 2nd edition, Newcastle upon Tyne

Bruce, J. C. 1885 *The Hand-book to the Roman Wall*, 3rd edition, Newcastle upon Tyne

Budge, E. A. W. 1903 *An Account of the Roman Antiquities preserved in the Museum at Chesters, Northumberland*, London

Budge, E. A. W. 1907 *An Account of the Roman Antiquities preserved in the Museum at Chesters, Northumberland*, 2nd edition, London

Clayton, J. 1844 'Account of an Excavation recently made within the Roman Station of Cilurnum', *Archaeologia Aeliana* 1st ser., 3, 142–7

Clayton, J. 1876a 'Notes of an excavation at Cilurnum', *Archaeologia Aeliana* 2nd ser., 7, 171–6

Clayton, J. 1876b 'Notes on the excavation of a turret on the Roman Wall', *Archaeologia Aeliana* 2nd ser., 7, 256–60

Edwards, B. J. N. 2009 'John Collingwood Bruce: Some sidelights', *Archaeologia Aeliana* 5th ser., 38, 129–38

Edwards, B. J. N. and Breeze, D. J. 2000 *The Twelfth Pilgrimage of Hadrian's Wall, 1999: A Report*, Kendal

Ewin, A. 2000 *Hadrian's Wall: A Social and Cultural History*, Lancaster

Graafstal, E. P. 2012 'Hadrian's haste: A priority programme for the Wall', *Archaeologia Aeliana* 5th ser., 41, 123–84

Hall, M. 1982 *The Artists of Northumbria*, 2nd edition, Bristol

Hill, P. R. 2006 *The Construction of Hadrian's Wall*, Stroud

Hingley, R. C. 2012 *Hadrian's Wall: A Life*, Oxford

Hodgson, J. 1840 *History of Northumberland*, vol. 3, part 2, Newcastle

Hodgson, N. 2003 *The Roman Fort at Wallsend (Segedunum): Excavations in 1997–8*, Newcastle upon Tyne

Horsley, J. 1732 *Britannia Romana*, London

Hutton, W. 1802 *The History of the Roman Wall*, London

McIntosh, F. 2014 'The Wall's first great collection: The Clayton Collection', in R. Collins and F. McIntosh (eds), *Life in the Limes*, Oxford, 188–93

Miket, R. 1984 'John Collingwood Bruce and the Roman Wall Controversy: The Formative Years', in R. Miket and C. Burgess (eds), *Between and Beyond the Walls: Essays on the Prehistory and History of North Britain in Honour of George Jobey*, Edinburgh, 243–63

Neilson, G. 1912 'Obituary Notice of J. P. Gibson, F. S. A., A Vice-President of the Society', *Archaeologia Aeliana* 3rd ser., 8, 37–45

Potter, H. G. 1855 'Amboglanna', *Archaeologia Aeliana* 1st ser., 4, 63–75, 141–9

Poulter, J. 2010 *The Planning of Roman Roads and Walls in Northern Britain*, Stroud

Richardson, G. B. 1855 'Pons Ælii; an attempt to indicate the site of the Roman station at Newcastle upon Tyne, and the course of the Wall through that town', *Archaeologia Aeliana* 1st ser., 4, 82–101

Roach Smith, C. 1852 *Collectanea Antiqua*, vol. 2, London

Rushworth, A. 2009 *Housesteads Roman Fort – The Grandest Station: Excavation and Survey at Housesteads, 1954–95, by Charles Daniels, John Gillam, James Crow and others*, Swindon

Snape, M. and Bidwell, P. T. 2002 'The Roman Fort at Newcastle upon Tyne', *Archaeologia Aeliana* 5th ser., 31.

Spain, G. R. B., Simpson, F. G. and Bosanquet. R. C. 1930 'The Roman Frontier from Wallsend to Rudchester Burn', *Northumberland County History* 13, 462–565

Warburton, J. 1753 *Vallum Romanorum*, London

Welford, R. 1895 *Men of Mark Twixt Tyne and Tweed*, London: the entry on John Clayton is on pp. 575–84

Wilmott, T. 2001 *Birdoswald Roman Fort, 1800 Years on Hadrian's Wall*, Stroud

Whitworth, A. M. 2012 *Hadrian's Wall through Time*, Stroud

Woodside, R. and Crow, J. 1999 *Hadrian's Wall: An Historic Landscape*, The National Trust, London

Index